# Yesterday in
## BRIGHTON & HOVE

JUDY MIDDLETON

AMBERLEY

First published 2010

Amberley Publishing
Cirencester Road, Chalford,
Stroud, Gloucestershire, GL6 8PE

www.amberleybooks.com

Copyright © Judy Middleton 2010

The right of Judy Middleton to be identified as the Author
of this work has been asserted in accordance with the
Copyrights, Designs and Patents Act 1988.

British Library Cataloguing in Publication Data.
A catalogue record for this book is available from the British Library.

ISBN 978 1 4456 0076 5

Typesetting and Origination by Amberley Publishing.
Printed in Great Britain.

# Contents

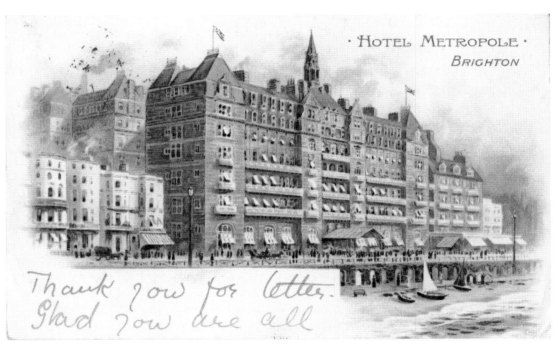

· HOTEL METROPOLE ·
BRIGHTON

*Thank you for letter.*
*Glad you are all*

This painting of the Metropole from 1906 cleverly suggests the shades of red brick and terracotta.

# Hotel Metropole

## Red Brick Surprise

The Metropole has mellowed over the years – this applies as much to the brickwork as to people's attitude towards the building. The striking appearance of red brick and terracotta no longer surprises us, but back in 1890 it was a different matter. People were used to pale stuccoed buildings that reflected the light, yet on the seafront stucco requires constant maintenance as the sea air does its best to lift the stucco off. Red brick is more durable and the architect Alfred Waterhouse must have been well aware of this when he made his decision. Then there is the sheer size of the hotel – a solid statement of confidence. But then Waterhouse was in the top league of Victorian architects, being responsible for the Manchester Assize Courts, Manchester Town Hall, the Natural History Museum, South Kensington, University College, London, and the south front of Balliol College, Oxford. It is amusing to note that when Hove Councillors decided to ask Waterhouse to design their new town hall, a world-weary councillor was heard to murmur that it was like getting a steam-roller to crack a nut.

The Metropole cost £57,000 to build. By January 1888 it had become a limited liability company and already some £24,000 had been allotted in £100 shares to six men who became the board of directors and earned £600 a year for their trouble, plus one-tenth of the annual net profit. Some shareholders in the Grand Hotel quietly withdrew their money to invest in the Metropole instead. Members of staff had the same idea. As the *Brighton Gazette* reported 'It does seem strange to be ushered into this handsome new building by the same tall, busy, familiar figure who has shown us in and out of the Grand any time these three years and to see in the front line of officials ... one of the most diligent of the Grand's booking clerks.'

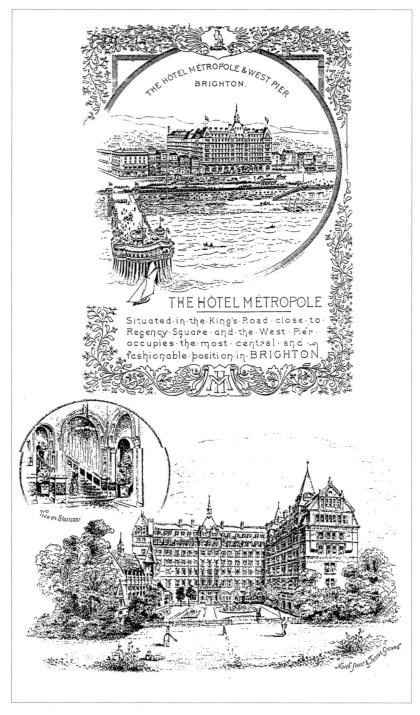

Even from a line drawing, it is clear to see that there had been nothing quite like the Hotel Metropole at Brighton.

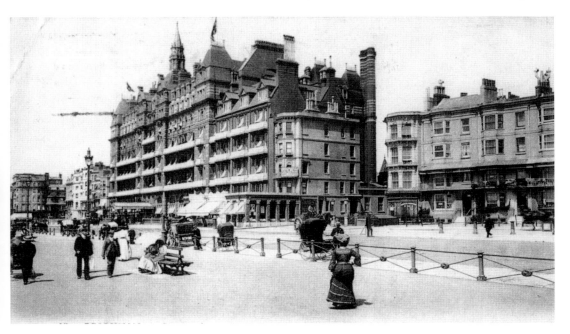

Most photographs of the hotel are taken from the south west – this one shows a more unusual aspect from the south east.

It has often been asserted that the building of the Metropole was beset by labour disputes. If there were, the local newspapers failed to mention them although they gave full reports of the London dock dispute. However one hint of discord is mentioned after the hotel was officially opened, when Brighton magistrates had to adjudicate on a wages dispute between some carpenters engaged at the hotel and the builder Thomas Holloway. The plaintiff was Harry Winchester of 52 Upper Russell Street, who stated that his wages had been reduced from 9*d* an hour to 8*d* without proper notice and therefore he claimed 5/2*d* in back pay. Two fellow workers backed him and the magistrates found in favour of the plaintiff. There was also a fatality. In April 1890 Samuel Bates, a zinc worker from London, was working on the dormers from a scaffold running round the roof when his saw became caught and, in trying to extricate it, he overbalanced and fell 70 feet to the ground. The jury at the inquest recommended that a rope should be fixed to the scaffolding at a height of 4 feet from the platform on which the men were working.

The Hotel Metropole opened at Monte Carlo in 1889 and the one in Cannes opened around Christmas time that same year. The Brighton Metropole opened in August 1890 and the London one followed later. Gordon Hotels owned all these establishments, plus the Grand and First Avenue Hotels (both in London), and the Burlington in Eastbourne, while the Royal Pier Hotel at Ryde on the Isle of Wight would be added to their portfolio later.

 HE HÔTEL MÉTROPOLE is entirely Fireproof and every care has been taken to render it thoroughly complete and comfortable. There are numerous Suites of Apartments, consisting of DRAWING ROOM, DINING ROOM, several BED ROOMS, BATH ROOM, &c., as also a large number of Double and Single BED ROOMS, most comfortably furnished and at moderate prices.

## BATHS.

IN addition to the numerous private Bath Rooms, there are on every Floor several Bath Rooms for the general use of Visitors. All Baths have Hot and Cold Salt Water, as well as Hot and Cold Fresh Water laid on.

## TURKISH BATH.

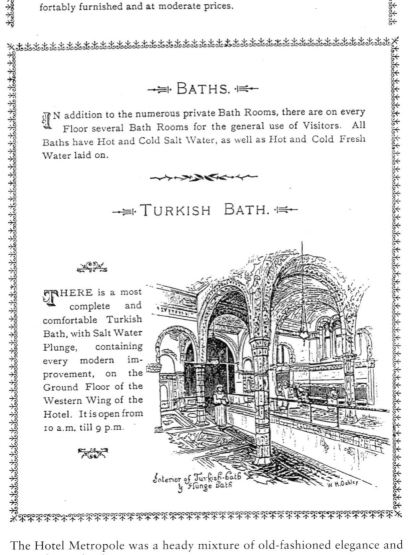

THERE is a most complete and comfortable Turkish Bath, with Salt Water Plunge, containing every modern improvement, on the Ground Floor of the Western Wing of the Hotel. It is open from 10 a.m. till 9 p.m.

Interior of Turkish Bath & Plunge Bath
W. H. Oakley

The Hotel Metropole was a heady mixture of old-fashioned elegance and up-to-date technology.

Some 1,500 people travelled down from London aboard a special train to attend a preview of the Brighton Metropole. The local populace also gathered in force because a rumour had gone around that the Prince of Wales would be there – unfortunately this was not true. Rumours also claimed that there were 4,000 bedrooms and enough electric lamps to light the whole of Brighton. Others believed the hotel had cost more than the entire national debt and that the Turkish bath could hold 1,000 bathers at the same time.

One reporter at the preview found himself quite disgusted at the amount of food and drink consumed by some guests, the various buffets being excellent and of abundant variety. The Metropole's own band played music in the ballroom, although if a guest had a military preference he could stroll to the central dining room where the band of the Coldstream Guards was performing. As dusk fell, the electric lamps began to blaze forth and the illumination of the Italian garden north of the hotel produced a sparkling effect.

There were three dining rooms and they were capable of seating 500 guests at one time. Maple's designed all the furnishings including the high-backed dining room chairs emblazoned with the hotel's badge in beaten gold. The dining rooms were decorated in colours ranging from golden brown to ivory white, with silk curtains to match. The *Brighton Herald* was lost in admiration at the décor with a 'moulded ceiling in cream and gold from which depend a number of dazzling electroliers, the cut prisms of which flash all the colours of the rainbow.'

The drawing room had an Arabian theme and the ceiling was painted in creamy tones with a raised band in solid gilt, while at the north end was an annexe called an oriental lounge with another Arabian ceiling. To add to the exotic effect there were stained glass octagonal lights and two hanging Moorish lamps.

In the smoking room some of the comfortable easy chairs were covered in fine, old Persian saddle-bags and rugs. Downstairs, below the well-appointed billiard room, there was the Turkish bath with an appropriate Eastern theme.

The Arabian theme was right up to date because in 1888 Charles Doughty published his *Travels in Arabia Deserta* and Sir Richard Burton presented the public with the last books of his 16-volume *Arabian Nights Entertainment*. The character of Scheharazada was guaranteed to capture the public imagination with her extraordinary tales – we are told that it was the king's custom to kill his bride the morning after consummation had taken place but Scheharazada managed to stave off the evil hour with her fabulous tales. Then there was the exotic scent wafting spicily about the expensive rooms created by the Metropole's perfumier and named 'The Light of Asia' as a compliment to Sir Edwin Arnold who had first suggested it. His most famous work published in 1879 was *The Light of Asia*.

However, there was still plenty of space for inspiration from other places and other times. For example, in the smoking room there was a huge fireplace made of oak, in the inglenook style, that stretched from floor to ceiling, while

the chimney piece in the library was Renaissance style in finely carved oak. But the most important chimney-piece was made of marble and was to be found in the drawing room. Not only was the marble statuary finely executed, it was also the work of Prince Victor Hohenlohe-Langenburg whose aunt was Queen Victoria. The prince made his first career in the Royal Navy and he saw active service in the Crimean War. He reached the rank of captain and after retiring through ill-health, he was made an honorary admiral. He then embarked on a new career in sculpture, helped by Queen Victoria, and he had his own studio adjoining his quarters in St James's Palace. This was perhaps his last private commission because he died in 1891. It is indeed unfortunate that when the hotel was re-modelled in the 1960s this charming piece was discarded.

Victorian artists were commissioned to decorate the public rooms. Thus in the drawing room were three panels by Albert Kingsley of Arundel Castle, Ashburnham Place and Eridge Park, while the Temple Brothers provided coaching scenes for the smoking room.

A central feature of what has been dubbed a public palace was the magnificent staircase constructed of polished marble with balusters of alabaster. No doubt Victorian guests ascending its stately treads were reminded of the popular aria 'I Dreamt that I dwelt in Marble Halls.'

Upstairs the number of rooms (not counting those of the servants) came to almost 700. Neither were all these merely single bedrooms because there were a number of suites on each floor that contained a drawing room and one or two en suite bedrooms. Some of the drawing rooms had walls hung in brocaded silk while the furniture varied in style from Sheraton to antique mahogany of the rococo period. The state suite boasted of a reception room and a dining room as well. The former had plenty of gilded furniture and the walls were hung with Persian embroidery while the latter was fitted out in the style of Louis XV with furniture in Italian walnut and a chimney-piece carved from Numidian marble.

A special mention must be made of the bathrooms where guests could choose not only ordinary hot and cold water but also hot and cold sea-water. The medicinal qualities of sea-water had long been recognised at Brighton and bringing the sea to one's bathroom was merely the logical extension.

A single room cost 3/6d a day while one of those splendid suites would set you back anything from £3-8s a day. But there was the consolation of knowing one's own servants were close at hand and could take their meals in the steward's room for only 6/- a day.

The Italian garden was on the north side of the hotel. It was stated that 'this restful garden with its twin parterres, stately bridge and placid water, is a most agreeable feature.' It was shielded from the blustery seafront and must have proved a welcome relief to ladies who wished to take the air without being buffeted by it.

August bank holiday came shortly after the Metropole opened its doors. Two colourful processions moved along King's Road and the press reported

it was a sight that even the 'nobility and gentry who hung about the steps of the Hotel Metropole were not quite indifferent to.' One procession belonged to Sanger's circus with cages full of lions and tigers and there were elephants and camels in the cavalcade attended by 'troops of Negroes and white men in brilliant uniforms.' The other procession advertised a skating rink. There were 'six hackney carriages containing instalments of a band of musicians, who tried to play together, but under the circumstances found that to be a little beyond their powers.' The carriages were followed by around thirty men dressed in dark blue plush uniforms and many boys in sailor suits.

The year 1890 seems to have been something of a vintage year for the hotel. Important guests included Prince Esterhazy, Prince Antoine D'Orleans, the Infanta d'Espagne, Princess Alexis Dolgourouki and Prince Ilbrahim, not forgetting the ambassadors from Russia and Turkey.

Some of the very first of the Metropole's guests in the first week of August 1890 were the Countess of Stradbroke, Lady Gwendoline Rous, the Hon Charles Willoughby, Count Appongi and the Comtesse de Brémont. The latter was an interesting lady who frequently appeared on the Brighton social scene that year. For her August stay she was mixing business with pleasure, because later in the month she gave a lecture in the Music Room at the Royal Pavilion about the goldfields and social life in the Transvaal. It was a select audience, which meant the room was not crowded, but they enjoyed the Comtesse's jokes such as marriage without love being like soup without salt.

Another lecturer who was resting at the hotel in January 1891 was Charles Dickens – not of course the famous author, but his son who had come to unwind after an arduous lecture tour. He was gratified to find the sun shining and said he had not enjoyed so much sunshine anywhere for a long time

Out of the foreign royalty who stayed at the Metropole, probably the most interesting were the Indian princes. The Maharajah of Cooch Behar arrived in September 1900 followed shortly afterwards by the Gaekwar of Baroda who spent most of November at the hotel. The Gaekwar brought his Maharani and their children – four princes and one princess. It would be interesting to know if the family were accompanied by any of the jewels from their exquisite collection. For instance, the Gaekwar owned a diamond collar composed of 500 large diamonds from which hung the Star of the South, a diamond of 128 carats.

The Clarence Rooms with a separate entrance in Cannon Place were an important feature of the hotel and they could be hired for private functions. There was a handsome reception room with an octagonal roof, an imposing ballroom with a beautifully modelled wagon-head roof, and beyond the ballroom was the crush room where guests could sit out the dancing and partake of light refreshments. There were also a number of private dining rooms for smaller parties.

One of the first people to take advantage of the Clarence Rooms were Mrs and Miss Campbell of 16 Eaton Gardens, Hove, who gave a charming 'At Home' in January 1891. The Campbells hired the Fraser Quintet from London

to provide the music and the guest list included Lady Pocock, Lady Napier and General and Mrs Holland.

Later in the same month, the Brighton Troop of the Middlesex Yeomanry Cavalry gave a Cinderella Dance in the ballroom (the guests departed at midnight). Notable among the many beautiful gowns were Mrs Cargill's of white silk trimmed with pale blue feathers, Miss Twaite's of black velvet and mauve with ostrich plumes, while Miss Minnie Freeman wore a gown of rose pink with spangled net and Miss Williams was adorned in a gown of lemon veiling trimmed with snowdrops. It must have been a colourful sight with the men in their military uniforms too.

The Metropole was frequented from its earliest days by society people and, let it be said, the eccentric. Miss Lamond belonged to the latter category. She was a lady of means and more or less lived at the hotel during 1896 as she was under the delusion that slanderous allegations were being made against her character. She engaged the services of Moser's Detective Agency and enlisted the help of both Mr and Mrs Moser to combat the situation. Mr Moser was despatched to Cairo and no doubt realising he was on to a good thing, he charged Miss Lamont 21 guineas a week while the total expenses of his journey was put at 200 guineas. The fee for the English enquiries came to one guinea per agent, plus 2nd class rail travel and 12/6d for hotel expenses. Miss Lamont settled the accounts – all except for the final £64, which she refused to pay. Mrs Moser brought an action against her in the Court of the Queen's Bench and Miss Lamont hired a Queen's Counsel for her defence. In the end Mr Justice Charles, while making comments about Miss Lamont's mental capacity, referred the whole matter to official referees.

## Cars and Carriages

On 14 November 1896 the emancipation of the motor car took place – although the Act of Parliament described them as light locomotives. It meant that cars were allowed to use the public highway without the attendance of three persons, one of whom had to precede the vehicle by at least 20 yards – whether or not this personage was still waving a red flag in the 1890s is open to debate. To celebrate the event a group of cars made their way from the Hotel Metropole, London, to the Hotel Metropole, Brighton, and the day is still commemorated by the annual veteran car rally that takes place on the first Sunday in November.

There was a great deal of public interest in the event and it was rashly claimed that fifty-four cars were to take part. As it happened twenty-one failed to turn up at all and of the twenty-two vehicles that left Brixton, twenty managed to reach Brighton. It was piously hoped that drivers would not overtake the car driven by Harry Lawson, president of the Motor Car Club, which had organised the run. In the event that proved impossible because Mr Lawson lost a bolt from his

cylinder and chugged into the Reigate lunch stop some three quarters of an hour behind the first arrival. But he did manage to be the fourth car into Brighton.

The Motor Car Club awarded gold medals to the first eight arrivals. The vehicles were a Bollée Voiturette, another Bollée, a Panhard omnibus, Harry Lawson's car, a Panhard and Levessor, a Britannic bath chair, a Daimler phaeton and a Pennington tricycle. It should also be noted that some 10,000 cyclists were said to have been on the road to Brighton at the same time as the car run was taking place. Such a sight would have gladdened the heart of Mr Lawson (despite losing his bolt) because he was the inventor of the safety bicycle and rumoured to be on the way to becoming a millionaire. A celebratory dinner was held at the Metropole, presided over by Lord Winchilsea, with the mayors of Reigate and Brighton in attendance.

As a contrast to the dismal weather conditions of the run, Monday 16 November 1896 was a fine day and a great part of Brighton's population descended on the King's Road to look at the motor cars drawn up outside the Metropole. The police were out in force and they were obliged to halt traffic from time to time to allow people to cross the road. The *Brighton Herald* summed up the general attitude to these peculiar vehicles; 'At present the horseless carriage is certainly not a thing of beauty. One of the first things to be done must be to design a car that will have at least the appearance of completeness, and not that of a trap or ordinary van with the horse left out.'

It might be thought that with the coming of the railway to Brighton in 1841 and then the arrival of cars, the coach and four would soon be consigned to history. But this was not so and well-turned out equipages continued to be seen along the King's Road. By the 1890s coaching was something of a prestigious art and great care was taken to match the horses. Take the *Nimrod* for example, which had matched pairs of greys or roans drawing a coach painted

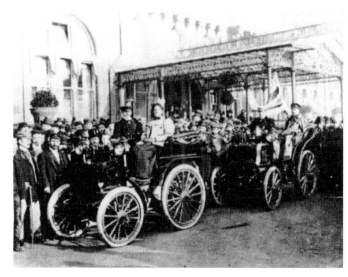

These splendid motor cars took part in the famous Emancipation Run and were photographed outside the Metropole on 16 November 1896. (*Brighton Library*)

primrose yellow with guards decked out in plush yellow coats. This splendid coach was to be seen drawn up outside the Metropole in the 1890s with the famous Ted Fownes, wearing a silk hat, sitting majestically in the driver's seat, lightly holding the reins and long whip. Ted was one of the old school and had grown up with coaching. He was born in 1851 and being out on the road in all weathers did not seem to do him much harm for he lived until his ninety-second year, dying in 1943.

Ted Fownes would have remembered Hatchett's White Horse Cellars in Piccadilly, which was a famous rendezvous for the coaching fraternity. When the premises changed hands in 1890, the coaches were obliged to find a new starting point. Some of them migrated to the Hotel Metropole in Northumberland Avenue and so a fitting conclusion to a pleasant outing was to finish up at the Hotel Metropole, Brighton. The staff in the cigar department of the London Metropole were most helpful in dispensing timetables to prospective customers.

Even with good patronage, coaching was an expensive business. It really did not pay its way but there were still plenty of wealthy men eager to have the chance of owning a prestigious coach and doing a spot of driving now and again. For example, Captain J. Spicer and Captain Hamilton financed the *Nimrod*.

In 1908 the conservative world of coaching was shaken up by the arrival of American money in the shape of Alfred G. Vanderbilt. His horses were American trotting horses and were swifter than the good old English coach horses. Strength was no longer paramount because road surfaces had been improved and besides Vanderbilt set his horses on shorter stages so they did not tire themselves out.

Vanderbilt's first coach was the *Venture*, which called regularly at the Brighton Metropole. Later on he added the *Old Times* and these two coaches and their beautiful teams became one of the sights of Brighton. There was huge excitement when the first Vanderbilt coach came to Brighton and it was the 'millionaire whip's first business run.' The *Venture* left London at 11 a.m. on 8 May 1908. The first team were the famous greys, with their manes braided with red and white ribbons and their heads adorned with red and white carnations while the coach was painted maroon and white with red lines. There were eight changes of horses on the way, the last being at Pyecombe where the company adjourned for tea at the Plough. Alfred Vanderbilt occupied the box seat dressed in a grey frock coat and grey top hat. Guard Godden wore his Venture uniform of a single-breasted frock coat of French grey with maroon cuffs, collar and lappets, black gaiters and boots and a beaver hat. As the *Venture* sped along King's Road, Godden was observed playing the 100-year old bugle with all his old skill. Vanderbilt never forgot the enthusiastic reception he received from crowds outside the hotel.

While Vanderbilt was running his coaches he and his wife occupied a house in Kemp Town. Young Master Vanderbilt had his own private brougham with

a basket-work body and the paintwork in Vanderbilt maroon. He was often seen taking the air in this carriage accompanied by his nurse and two male servants. Locals were amused to see that the servants on the box wore white hats whereas an English servant in that situation would have worn a black silk top hat.

Vanderbilt's enthusiasm for the sport can be gauged from the fact that he once had shipped across the Atlantic twenty-six horses, sixteen coaches, plus a team of grooms and assistants. In 1913 Vanderbilt sold the *Old Times* to Lord Leconfield, Lord Lieutenant of Sussex, who was also a keen sportsman and relished the chance of driving the coach, which still came to the Brighton Metropole. It was mostly Ted Fownes up on the seat and Lord Leconfield thought the world of him, writing this touching tribute

> During all these years I never saw him worried, nor did I ever see one of the grooms at the changing places in any way rude to him. As a coachman it was a wonder to see him drive; I have seen him have some very tough rides, but he never worried: the only thing that you noticed was that he became very silent and the muscles at the back of his neck swelled right up.

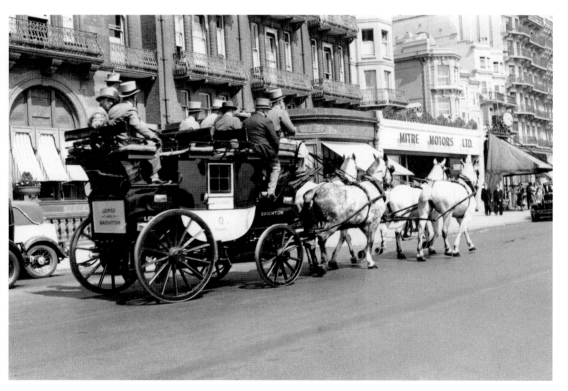

Vanderbilt's coach *Venture* and some of his splendid horses pictured in 1909. (*Brighton Library*)

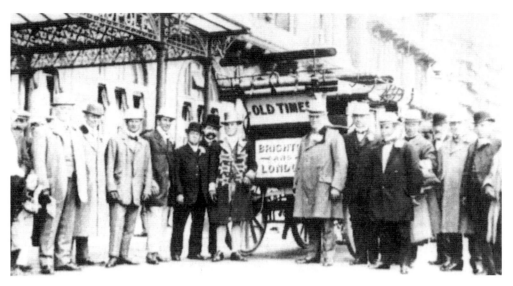

The coach *Old Times* in around 1913 when it had been purchased by Lord Leconfield. Ted Fownes stands in the centre to the right of the notice. (*Brighton Library*)

The glory days ended abruptly with the outbreak of the First World War when, in 1914, the Army commandeered all the horses from the *Venture* and the *Old Times*. It must have been heartbreaking for all concerned. Vanderbilt was very attached to all his horses and understood the temper of each one.

But Vanderbilt was nothing if not generous and he came up with the idea of providing motor ambulances for the front. He wanted to supervise the undertaking personally and so on 1 May 1915 he set sail on the ill-fated *Lusitania*, which was torpedoed by a German submarine on 7 May. As the *Lusitania* began to list badly, there was general panic aboard as people scrambled for the lifeboats. Vanderbilt appeared quite calm, dressed in a grey pin-stripe suit and polka-dot tie as if he were going to Ascot. He told his valet Ronald Denyer to gather all the children he could find and Vanderbilt was seen hurrying to the lifeboats with two children in his arms. He died a hero's death because although he could not swim, he insisted on giving his life-jacket to Alice Middleton, a young nurse who survived. His body was never found although his distraught family offered a reward of 5,000 dollars for its discovery. Altogether, 1,195 people were lost.

The *Brighton Gazette* had this to say.

It is with the greatest sorrow that Brightonians realise that Mr Alfred Gwynne Vanderbilt, who has been for so many years such a well-known figure in the town, now is no more. His calmness under all circumstances was remarkable, and this was often shown by the manner in which he handled his horses at moments when calm judgement was the one thing that evaded a possible accident.

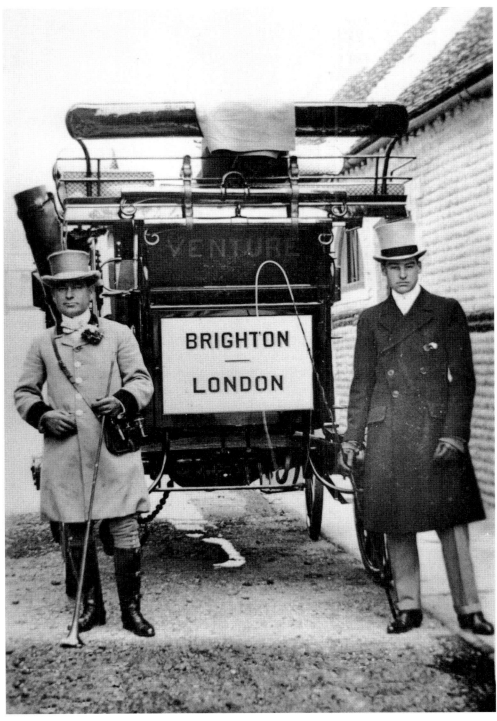

The coach Venture with Alfred Vanderbilt on the right and Walter Godden, the guard, on the left. (*Brighton Library*)

## A Bevy of Beauties

Many a Gaiety Girl swept into the Hotel Metropole, trailing expensive perfume and ardent admirers. The Gaiety Girls were not ordinary show-girls or actresses. They really were the crème de la crème and the aristocracy did not hesitate to select brides from their ranks. They were all hand picked by George Edwardes, known in theatrical circles as 'the Guv'nor', who had a discerning eye for female beauty. Once selected a Gaiety Girl was put through a rigorous course of instruction from the best teachers – learning to breathe properly, speak correctly and dance lightly. Some were even sent off to France to learn French. A Gaiety Girl had to live up to her image and the Guv'nor advised her always to dine at Romano's in the Strand because that was the smartest place to be seen in town. He also happened to have an arrangement with the restaurant whereby a Gaiety Girl enjoyed a special tariff. Not that she was likely to be short of an escort. Indeed it gave a man tremendous cachet to be seen about with a Gaiety Girl on his arm. The Guv'nor paid for the dresses worn by his girls during the four days of Ascot. Not a trifling gift when you consider every stitch and tuck was done by hand. Edwardes must have regarded it as an investment because the Gaiety Girls were seen to be leaders of fashion as well as stars of the stage and they were used to moving in the most exclusive circles.

Constance Gilchrist was a Gaiety Girl and Sir C. B. Cochrane remembered seeing her at the Metropole not long after it opened. Cochrane had more than a passing interest in the fortunes of the hotel because as a bored sixteen-year old he worked for the surveyor's office where the plans were being drawn up. He had been obliged to leave Brighton Grammar School (and the companionship of Aubrey Beardsley) because his parents were financially embarrassed and he had to start earning a living. All he was really interested in was the theatre and eventually he became a celebrated impresario.

Constance Gilchrist rose to fame by performing the skipping-rope dance for which she wore a short costume, mauve tights and little black-laced boots. The artist Whistler immortalised her in his painting that started off with the title 'The Girl with the Skipping Rope' but was later changed to 'The Girl in Gold.' Constance was very popular, a name on everyone's lips with the exception it seems of the judiciary. The public loved the story of how Mr Justice Coleridge was sitting in court when the name of Connie Gilchrist was mentioned to illustrate a point. 'And who' queried the judge 'is Connie Gilchrist?' It became a catchphrase. So well did Miss Gilchrist do with her career that she was able to hang up her skipping-rope at the age of twenty-two and on 19 July 1892 she married the 7th Earl of Orkney.

An equally successful Gaiety Girl was Rosie Boote whose career was in no way hindered by such an inelegant name. Anyway she soon changed it by marrying the Marquis of Headfort. She too visited the Metropole.

In 1916 Gertie Millar was spotted sipping tea at the Metropole. She had been discovered by the Guv'nor and she was a beautiful dancer as well as being

lovely to look at. She was the daughter of a Bradford mill worker and she went on the stage at the age of thirteen. She retired in 1924 and married the 2nd Earl of Dudley in the same year.

Another Metropole visitor was petite Gabrielle Ray, who received the ultimate in stage door presents. Gaiety Girls were accustomed to be being showered with gifts and Guards officers jostled at the stage door with the likes of the Rajah of Cooch Behar. In Gabrielle's case her gift was a complete grapevine that had taken eight years to grow, trained in a half hoop over a basket. It yielded 20 bunches of black grapes and needed four strong men to lift it.

Lily Elsie also visited the Metropole. She was an entrancing principal boy in *The New Aladdin* but her greatest success was as Sonia in *The Merry Widow* which ran for 778 performances. The first performance took place on 17 June 1907 and Edward VII was such a fan he saw the show four times. Ladies rushed to copy Elsie's large cartwheel-shaped hats. No doubt the hats were entrancing but it was hard luck on people sitting behind a woman wearing one in the theatre. Ladies did not normally remove their hats on such occasions. The management of the Theatre Royal, Brighton, used to insert a request in their programmes asking ladies and gentlemen to remove their hats but ladies often chose to ignore it.

Other stars of the stage, who visited the Metropole, were Julia James and Phyllis and Zena Dare. Julia James was a leading lady at the Gaiety and had wonderful red hair that attracted admiring glances wherever she went. Zena Dare was well-known for playing Peter in Barrie's *Peter Pan*.

In 1916 the great social occasion at the Metropole was Sunday afternoon tea, to which society and theatrical stars came in great numbers – including Blanche Tolmin who appeared as Cleopatra at the Shaftesbury later that year and Mademoiselle Alice Delysia, the French actress and singer managed by Cochrane for many years. Among the brightest stars was Vesta Tilley, who took Sunday afternoon tea at the Metropole in May 1916. She first appeared on the stage at the age of three. She toured the country with her father who was billed as Harry Ball the tramp musician. He also had a wonderful performing dog called Fathead. She chose her first name herself after the Vesta match – she said it was a striking name. She was a noted male impersonator who portrayed the immaculate man about town. Indeed her costumes were so well tailored that she became a leader of men's fashions in the 1890s. Vesta married Colonel de Frece in 1890; he became an MP and was later knighted. Lady de Frece lived to the age of eighty-eight and died in 1952.

Another lady who greatly enjoyed Sunday teatime at the Metropole was Countess Poulett. In February 1916 she was gowned in deep sapphire velvet, sables across her shoulders, a long rope of pearls, diamond ornaments and a high black toque. Two months later the Countess wore a lace dress over a satin underskirt and a couple of weeks later she was seen in a rose-pink dress veiled in flounced black net while the swathed corsage was arranged with a rose-pink sash and fastened with a brooch of diamonds and pearls.

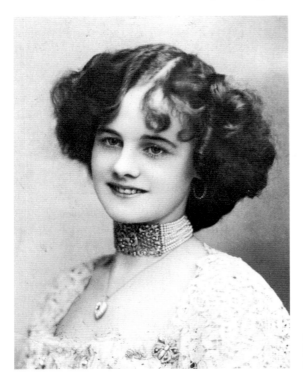

Gertie Miller. She rose from a humble background to become a member of the aristocracy.

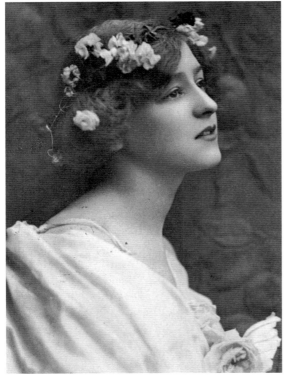

Gabrielle Ray received the exotic gift of a whole grape vine from an admirer.

Lily Elsie had great success as Sonia in *The Merry Widow,* which King Edward VII saw four times.

Zena Dare was well-known for playing Peter Pan. She sometimes appeared on stage with her younger sister Phyllis Dare.

The Countess started life as plain Sylvia Storey, the daughter of Fred Storey, the actor and dancer. Like other theatrical beauties, Sylvia used her career as a Gaiety Girl to climb the social ladder. She became Countess Poulett in the greatest secrecy but when news of the marriage leaked out, it caused a sensation. Perhaps these great ladies of the theatre knew how to play an aristocratic role better than those born with blue blood in their veins.

Lillie Langtry was not a Gaiety Girl but her name eclipsed the other bright stars and is still remembered today. By the time she stayed at the Metropole, her days of greatest fame were over because the eyes of the Prince of Wales had wandered elsewhere. They first met on 24 May 1877 and although an acknowledged beauty, she seemed an unlikely candidate for a Prince's amour, being the daughter of the Dean of Jersey and a respectable, married woman of three years standing. When her friendship with the Prince became known, people were terribly curious to see what she looked like. Whenever she went shopping or riding in the park, people followed and stared. Lillie herself said that people would lift her sunshade to have a good look at her face. Even great ladies like Lady Cadogan were known to climb onto iron chairs in the park as Lillie went by. Her soubriquet 'The Jersey Lily' arose because it was Millais' title for the portrait he painted of her – they both shared a Jersey background.

Lillie was obviously a lady of wit as well as being beautiful. Bernard Falk, reporter and author, remembered how she kept everyone amused on a voyage to the United States. When she was presented with an immigration questionnaire, she answered as follows.

'Distinguishing body marks: a pair of big blue eyes.

Colour of hair: a matter of opinion.

Complexion: troublesome.'

In contrast to the Gaiety Girls who often retired from the stage once they entered society, Lillie went on the stage for the first time in 1881, making her debut in *She Stoops to Conquer*. She was never a great success as an actress but her name could still attract an audience. She appeared at the Theatre Royal, Brighton in 1892 and the local press ignored her acting skills while recording that the audience was startled by her wealth of diamonds. She was again in Brighton in December 1896 and this time she appeared at the Royal Pavilion in the role of narrator. She was greeted with tepid applause and reviews were unkind – 'her efforts as an actress can scarcely be said to have ever put her in the front rank.' Poor Lillie.

As a footnote to stage beauties, it is worth recording that the Metropole was once home to a farce of a different sort – in short, a place to provide evidence of adultery in divorce cases. Nothing was advertised of course, everything was done discreetly and other large hotels at Brighton were familiar with the routine as well. It is most probably this underlying fact that provided the phrase 'a dirty weekend at Brighton.' In the 1920s a new law was introduced whereby wives achieved equity by being allowed to divorce their husbands because of a single

Lillie Langtry was famous for catching the attention of the Prince of Wales rather than for her acting abilities.

act of adultery. If a couple wanted to end their marriage but the husband had not committed adultery, the practice was for him to hire a woman and take her for a weekend trip to an expensive hotel by the seaside. All that was required of the woman was for her to be seen in the same bed as the man when the maid brought in the early morning tea tray. This was known as a 'hotel bill case' and the bill or the chambermaid's evidence could be cited as evidence in court. The farce was that usually nothing improper had taken place at all and they might have spent the night playing cards, drinking or sleeping in separate beds.

## Wartime Years

There was a marked contrast between activities at the Metropole during the two world wars. In the First World War, and despite the appalling losses at the front, social life continued much as before. Guests were free to come and go and if there was a sprinkling of khaki uniforms this only served to heighten the atmosphere. Some officers were on leave but others were recuperating from their wounds. There was a large military camp at Shoreham and officers were invited to the Metropole. At the New Year celebrations in 1916 held in the hotel's ballroom, Mrs Archibald Reith was resplendent in a gown of jasmine

yellow charmeuse – it was her husband who was in command of the 9th Buffs at Shoreham. There was a huge attendance and a large bell was hung on the platform to usher in the New Year with loud clangs. There was a moment's silence, then the lights blazed forth, three cheers were given for the king and then the company trooped off to supper. One wonders how young Lady Wheler felt as a bride of a few weeks with her husband Sir Trevor Wheler expected to leave for the front shortly.

In March 1916 a Mrs Barnes motored over from Eastbourne for Sunday tea at the Metropole and among her party were members of the Royal Flying Corps (the RAF was not formed until 1918). Another lady doing her bit for the war effort was Lady Barrett-Lennard, who arranged a matinée in the Clarence Rooms in aid of a fund for providing entertainment for wounded Canadian soldiers. The tickets cost 5/- and tea was included.

As far as fashion went in 1916, it seems the ladies who frequented the Metropole were vying with each other to appear in the most expensive furs. It can only have been the prestige involved because the hotel was well heated and there was such a press of company there was no need to go around dripping with furs. Imagine the scene in January 1916 when there was Mrs Woolley in a long coat of musquash adorned with skunk, Mrs Styan wearing her Russian bear furs, Mrs Seager P. Hunt from Boston USA in her wonderful sables, and Mrs Finch in rich white fox furs. Then there was novelist Miss Winifred Graham in a coat of real pony skin and actress Miss Blanche Tolmin in a velvet suit trimmed with grey opossum fur.

However, none of these ladies had the cachet of royalty. Princess Louise, Duchess of Argyll, stayed at the Metropole for ten days in August 1917. Her ladies-in-waiting Mrs Holden and Miss Styles accompanied her. Princess Louise was the sixth child of Queen Victoria and Prince Albert. She was born in the tumultuous year of 1848, the year of revolutions, and because of this Queen Victoria felt she might turn out to be somewhat different. She was the most artistic of her sisters and became a talented sculptor creating a statue of her mother in white Carrara marble that was much admired.

While she was staying at the Metropole, the Princess visited wounded soldiers at the Royal Pavilion and York Place hospitals. The *Brighton Herald* reported that 'with the wounded men – all of whom had lost a limb, in some cases alas two! – the Princess showed the tenderest sympathy, and she chatted to many of them in that friendly, unaffected way which at once put them at their ease.'

By 1918 home conditions had become more difficult. There were lighting restrictions and the use of petrol for frivolous journeys was frowned upon. There were food shortages and meatless days. In such circumstances a local reporter was shocked to find a Brighton lady giving a large party for her female friends at the Metropole – although it would have been acceptable had there been wounded officers present.

The Second World War was not to leave Brighton so undisturbed; indeed she was practically in the front line in more senses than one. Many of Brighton's

largest buildings, including hotels, schools, colleges, and private houses were requisitioned, and various units of the Army, Navy and Air Force moved in for the duration.

In 1941 the management of the Metropole was given precisely three weeks to vacate the premises. It was a dreadful scramble to try and clear such a large building in such a short time. Hannington's undertook the task but there was just too much to store in their depository alone and items had to be sent to Hudson's depository in Queen's Road, Abinger House in King's Road and the former Westcombe School for girls in Dyke Road. Although the depositories were secure enough, many items were stolen from the two houses – particularly Abinger House.

In October 1941 the Metropole became an aircrew-holding unit for the RAF. Previously there had been a similar establishment in a block of flats at Regent's Park but there was a lack of space and so the first large contingent were marched to Victoria Station, onto the troop train and down to Brighton and the Metropole. Airman Stanley Townsend lived at Brighton and although not officially in the first draft, he grabbed the chance of free travel home for the weekend, and attached himself to the marching men. He was not detected.

Squadron Leader Brian Walker, then a young lad aged nineteen, was in the first draft. A couple of months after arriving at the Metropole he contracted chicken pox and was despatched to a small hotel at Black Rock being used as an isolation unit. There he spent his twentieth birthday. The medical officer was a gynaecologist in civilian life and not being too familiar with the symptoms of chicken pox, called in his flight sergeant for a second opinion. The only other sick occupant of the small hotel had mumps and so Walker promptly caught that as well.

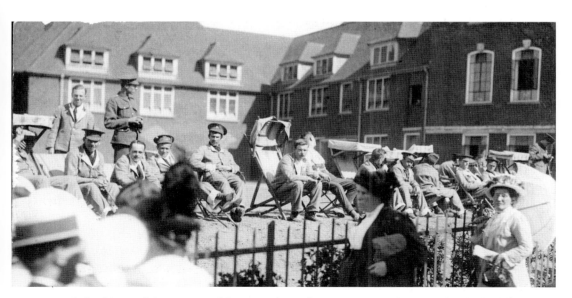

Wounded soldiers of the First World War at the 2nd Eastern General Hospital – the buildings belonging to the Brighton, Hove & Sussex Grammar School.

Princess Louise (1848-1939) was the sixth child and fourth daughter of Queen Victoria and Prince Albert.

Brian Walker's experiences were probably typical of many young airmen at the time. After his spell at the Metropole he was sent to the Elementary Flying Training School at Marshalls, Cambridge, then back to the Metropole before leaving for more training in the southern United States under the Arnold Scheme.

Meanwhile, back at the Metropole, the men were kept busy drilling, going on route marches, and attending lectures on such subjects as meteorology, navigation and aircraft recognition. Norman Wilkinson came up with a brilliant idea, which would regrettably keep him and his helpers away from all that excessive exercise. Wilkinson had been a designer for Tootal, Broadhurst & Lee in Manchester and now he wanted to paint pictures of aircraft to put on the walls of the aircraft recognition room. The idea was accepted and every morning at 8 a.m. the flight sergeant would shout 'Fall out the painters.' While the rest of the men drilled, the painting party disappeared downstairs. Wilkinson did the work – the rest of the 'painters' provided moral support and endless cups of coffee. Wilkinson did not favour a formal portrait of aircraft and instead painted action pictures with titles such as 'Thames Estuary Raided' 'Libyan Encounter' and 'Axis Convoy Raided.'

There is an amusing sequel to this story because when the hotel was handed back after the war, the owners became quite excited when they saw the Wilkinson paintings. They mistook them for the work of another Norman Wilkinson (1878-1971) a well-known artist who had the rank of air commodore in the war and was inspector of camouflage. During the Normandy landings, he was to be seen on deck, sketching furiously. He produced a set of fifty-three

oil paintings of Naval incidents and also some involving Coastal Command Royal Air Force. When the distinguished artist was contacted, he told them the Metropole paintings were not his work. Then they discovered the other Norman Wilkinson living peacefully in Cheshire and he and his wife were invited to Brighton to declare his exhibition open and give everyone a chance to view his wartime creations.

Another RAF officer remembered being at the Metropole in 1942 and 1943. He was based at the hotel but as a married officer he had quarters elsewhere. He worked in the accounts office located on the third floor. Looking out of the window one day he observed an old man being wheeled along the front and left to soak up the sunshine. Suddenly, a Messerschmitt 109 appeared from the direction of Shoreham flying low and firing rapidly. The convalescent was out of his bath chair in a trice and tried to dive under an adjacent seat.

Sergeant Thomas was still at the hotel when it began the next stage of its wartime career. On 31 May 1943 the Royal Australian Air Force took over, becoming 11 PDRC (Personnel Dispatch and Reception Centre) the unit having been at Bournemouth since July 1941. Although it was run by Australians, the unit was still part of RAF Brighton, which was commanded by Wing Commander T. W. White.

Dick Higgins, who was among the first batch of Australians at the hotel, remembered the unit was somewhat disorganised at first. After morning roll-call, the Aussies disappeared to the nearest pub where an education awaited them. When they ordered their first pint of beer, they were horrified to be given what looked like cold tea but they soon grew used to English beer. Favourite hostelries included one run by Tommy Farr, the famous Welsh boxer, and the Hole in the Wall (now the Queensbury Arms) near the hotel. Wally Brue had fond memories of the Hole in the Wall and he returned on a nostalgic trip in 1984. The man behind the bar told him he was by no means the first Australian to revisit his former haunts. It seems the Metropole was 'dry' during most of the war. There was a sergeants' mess at Lion Mansions and an officers' mess at Abbott's Hotel.

Frank Horley arrived at the Metropole at the end of 1943. He had crossed the Atlantic aboard the *Isle de France* and he travelled from Greenock to Brighton by train. At Brighton he and his compatriots (some 1,200 of them) learned about blackout restrictions at first hand when they marched from the station to the Metropole in pitch darkness. Although the distance is comparatively short, it seemed a long haul to the tired men.

Ray Sayer was another 1943 arrival. He sailed with 5,000 other Australians aboard the *Marisposa* to San Francisco, then across the United States by train and in New York they boarded the *Queen Mary* and sailed to Greenock. He arrived in broad daylight and found his first glimpse of the Metropole most impressive. Arthur Leebold in a contingent of 300 aircrew, came by the same roundabout route and arrived at the hotel in March 1944. The only difference being that he sailed aboard the *Queen Elizabeth*. When the Aussies claimed they had come half way round the world to fight the Germans, it was no more than the truth.

How did the Metropole strike all those men from down under? Of course they were not seeing it under normal conditions but even so the sheer size of the building together with the quantity of marble and the tall mirrors could not fail to make an impression. It was also a pleasant change from the normal accommodation in a Nissen hut. The hotel was heated, the baths were large and the food was good – although the lifts did not operate. It is not clear if this was for mechanical reasons or to improve the fitness of those billeted on the top floor. It cannot have been peaceful with the sound of enemy aircraft passing overhead on their way to London and Malcolm King remembered that after D-Day you could clearly hear the noise of gunfire across the Channel. Later there were the eerie V2 rockets too.

Some four or five Australians were crowded into one bedroom, some had double bunks while others had to make do with a mattress on the floor. Arthur Leebold shared a room with Doug, Tim, Jim and Peter. But sadly he was the only one to survive the war. When he returned to visit Brighton in more peaceful years he did not fail to drink a toast to his old comrades.

Vandalism was practically unknown but there was one prank the men were rather fond of – they would shout 'Bombs away' and fling metal rubbish bins down the stairwell with a glorious clatter. But the authorities soon got wise to this and had nets hung over the stairwell. One regrettable incident by an RAAF officer (and not a temporary gentleman either) occurred when he urinated from the balcony of one of the top floor rooms. It was said the CO's wife got her hat damp and the event caused some excitement at the time

Maurice Dunn remembered the scalding washing-up water in which each man had to wash his utensils. It was great having such hot water but there was a problem if you accidentally dropped your knife in. You were only issued with one knife and no replacements and many choice words were uttered when a knife had to be retrieved. Dunn had a novel way of dealing with his detachable collars, thus saving himself time and money. He would wash the collar in the hand basin, squeeze it as dry as possible and then stick it flat on his mirror. Next morning he would peel it off, fresh and ready to wear.

There was a machine gun on top of the Metropole, the idea being to pick off low flying aircraft. Bob Hannay, who was at the hotel in early 1944, remembered one night when a FW 190 did not like the treatment it was receiving from the hotel's gun, and wheeled about cannon blazing. A young greenhorn was manning the gun at the time and it was his first experience of being under fire. Later, he joined his friends at a dance, ashen-faced.

J. S. Otlowski also remembered a FW 190, this one giving a virtuoso performance of low flying. It flew low over the sea, almost skimming the waves, pulled up sharply over the Metropole, dropped a bomb in a park and then made off unscathed. Otlowski served in the Polish squadron of the RAF. He had already seen three years of active service with the 8th Army in the Western Desert (including the siege of Tobruk) before training as an airman. He arrived at Brighton in November 1943 and was posted to the Initial

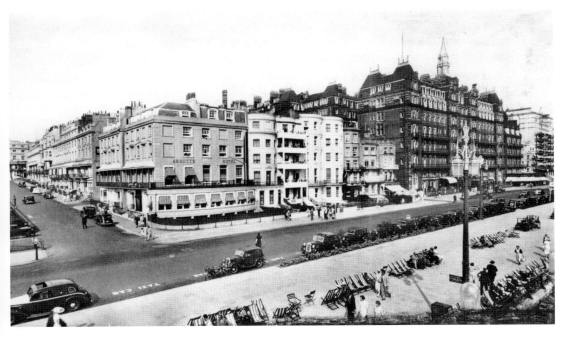

During the Second World War Abbotts' Hotel on the corner of Regency Square served as a RAAF Officers' Mess.

Training Wing at the Hotel Stratheden in Regency Square. As it was close to the Metropole it seemed sensible for the Poles to share messing facilities with the Australians there. The dining room also served as an examination room and it was there that Otlowski sat his navigation exam (in Polish). Both Poles and Australians attended the same pay parade held on the West Pier. In 1952 Otlowski emigrated to Australia where he met many ex-RAAF members. The first question was always 'If you were in the UK during the war, you must remember the Metropole.' In early 1944 United States Air Force bombers and their escorts assembled over Brighton. Otlowski remembered it as a magnificent sight – a cloudless blue sky with around 1,000 planes. A Lockheed Lightning fighter got into difficulties and plunged into the sea a few hundred yards off shore and opposite the Metropole. Royal Navy rescue boats put out at once from Hove but the pilot was never found.

The Metropole served as a reception centre for Australian aircrew. Either they were fresh from Australia, or they had completed their training under the Empire Air Training Scheme or they were between postings. An idea of the size of the establishment can be gauged from the figures recorded on 16 June 1943. There were the permanent staff of twenty officers, twenty-five NCOs and thirty-three other ranks, plus 947 aircrew and 206 officers who were passing through.

Flight Lieutenant David Bayer, the unit's chaplain, was an important member of the permanent staff. He had his work cut out because he was the only padre

but he emphasised that he was happy to talk to men of any denomination. His small office was always crowded with men who might have a problem, or wanted to look at Australian newspapers scattered around, or wished to take part in some sport. Bayer was a great sports organiser, arranging for men to take part in at least fourteen different sports, together with the relevant kit and transport. He wrote hundreds of letters to Australia, telling parents he had seen their son, had a chat with him and he was well and happy. Although church parades were not compulsory, Bayer was so popular that he had to allow extra time to accommodate the hundreds who wanted to attend.

By this time the unit was well organised with the issue of kit, hospitality, medical checks (including a night vision test) and training programmes all taken care of. Teeth were inspected at the Hotel and Australians attended in squads of 50. The New Zealand Dental Corps were also located at the Metropole and members of the RNZAF stationed at the Grand (12 PDRC) used to pop round for their inspection.

A scheme called the Dominion and Allied Forces Hospitality League made sure men did not feel lonely on leave in a strange country. As soon as men arrived at the Metropole they were informed they could send a reply paid telegram asking for hospitality during leave to Lady Frances Ryder or Miss Macdonald of the Isles. Lady Frances or one of her helpers used to welcome personally each batch of new arrivals. Ray Sayers remembered with pleasure meeting Lady Frances over a cup of tea at the Metropole and she introduced him to a very kind family with whom he spent no less than fourteen periods of leave. It was a great bonus for a rather weary young man.

The Australians left the Metropole briefly in May 1944 because of the run-up to D-Day and the unit moved to Padstow. However, by August 1944 they

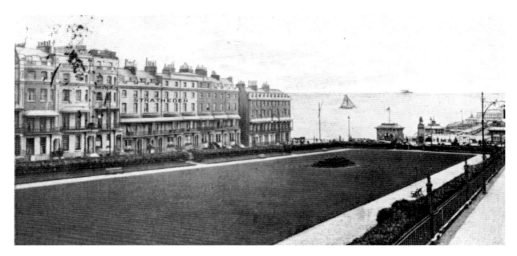

The Stratheden Hotel in Regency Square is featured here in 1909. In 1943 it housed the Initial Training Wing, part of RAAF 11 PDRC, which was based in the Metropole.

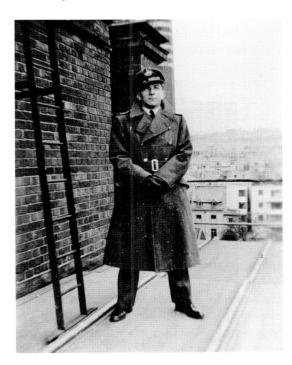

Flight Officer Darcy Packwood RNZAF
on top of the Metropole in 1945.
(*D. Packwood*)

were back again. On 12 April 1945 the hotel took on a new role as a Red
Cross centre for repatriating newly released prisoners of war. The men were
medically examined and debriefed by intelligence officers. People like Frank
Horley in the pay office tried to give good advice about being cautious with
their accumulated back pay and if possible to send it back to Australia so that
they could have a good start once they were out of uniform. But of course
there were some who told the staff what to do with their advice and insisted on
drawing out the whole lot.

Nobby Blundell had a marvellous reunion with his friend John Dack at the
Metropole on 31 May 1945. Dack had been in a Lancaster attacking Flushing
when they were shot down on 23 October 1944. Four of the crew were killed
but Dack and two others survived and were taken prisoner. Dack was taken to
Stalagluft 3 at Sagan, Ober Silesia. This camp was made famous by the Great
Escape and the Wooden Horse but those days were long over by the time he
arrived. A cold winter in north Germany was especially hard for Australians.
Dack put on all the clothes he had and was still frozen. Besides, he and his
fellow prisoners were under-weight. On 20 April 1945 the Germans left the
camp and the Russians marched in the next day. Dack arrived back in England
on 26 May 1945 – first stop the Metropole and the luxury of a hot bath with
real soap and a clean uniform. He was also greatly relieved to visit the RAAF
dentist who rushed through a new set of dentures for him – he'd had no teeth
since being shot down.

New Zealand prisoners of war were also installed at the Metropole. They were under the care of Wing Commander Arthur Colville but when he was involved in a serious car accident, his second-in-command Squadron Leader M. Innes-Jones took over. Innes-Jones remembered the prisoners of war being so emaciated – nothing more than skin and bone. Some had been in the horrific 800-mile tramp from Poland before the German front collapsed. Quantities of special food were brought over from New Zealand for these men including the luxury of tinned oysters. Although by then food in England was plain and in short supply, none of this special consignment was spirited away. A band of local ladies came in to make beds and arrange fresh flowers. The men had been so starved of female company that the chaplain and Innes-Jones had difficulty in persuading them not to propose to the first pretty face they encountered. By the end of June 1945 some 937 Australian prisoners of war had passed through the hotel.

There were also aircrew and officers at the hotel waiting for transport to be arranged. Some stayed a few weeks while others like Bob Hannay got away quite quickly. In Hannay's case he won a ticket on one of the first ships sailing to Australia but it was the only lottery he was not keen on winning because he had a seventeen-year old English WAAF sweetheart whom he did not want to leave.

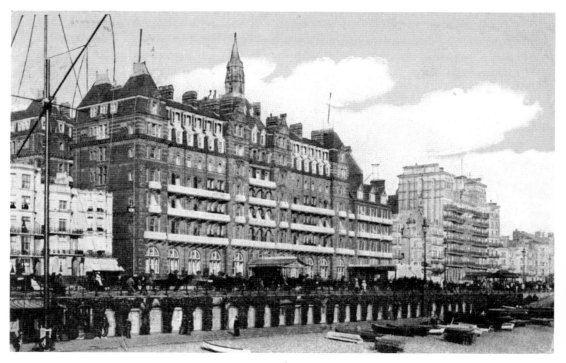

A fine view of the Metropole taken in 1906 from the West Pier.

George Cook found his six-week stay being extended to eight weeks. But he did not mind because he and some of his mates found themselves part-time jobs at the local brewery. They did not earn much money loading the barrels but there was plenty of free beer.

Although it was mostly the case that New Zealanders went to the Grand and Australians went to the Metropole, there was some interchange between the two. Thus Darcy Packwood of the RNZAF and some friends found themselves on the top floor of the Metropole in March 1945 and again in September of the same year before sailing home on the *Andes*. In 1946 the authorities handed back the Metropole and the long haul back to normality began.

## Recollections

Imagine the scene in the 1920s. Inside the Metropole's impressive entrance hall, there was a small bench on the right hand side near the desk where six boys sat dressed in a smart maroon uniform with brass buttons and peaked cap. These were the pageboys who took it in turns to run errands for the guests at a wage of 5/- a week. Joe Vinall became a pageboy in 1923 and it was the uniform that appealed to him. He thought the boys looked as smart as paint. He was the smallest boy and weighed under 5 stone, but he became a great favourite with the guests and did quite well with tips. Out of his wages he gave his mother 3/- and kept the rest as he was saving up to buy himself a bicycle. They could be bought for £3 in those days. But when the great day came, he was too small to ride it properly and his father bolted pieces of wood onto the pedals so that he could reach them.

The staff took their meals in a hall situated below pavement level. Joe did not like the food provided and knew where to get something tastier to eat. Bill Grenyer was a good friend who ran the Turkish bath. He was a war veteran whose injuries left him with a damaged leg but as he had worked for the Metropole before the war, they gave him a job there afterwards. The management ensured good food was sent to him at lunchtime but as he lived a short distance away in Upper Russell Street, he sometimes went home for lunch and then Joe would have the food instead.

A favourite trick of the pageboys was hiding in the dark, carpeted room adjacent to the dining room. They waited until the waitresses cleared away afternoon tea because they knew the girls passed through that room on their way to the kitchen. The boys would quietly remove a cake or two from the piled-up plates.

Joe's friend Arthur Knight was also a pageboy and his father ran the billiard room – you could say there was almost a family feeling among the staff. Indeed it was Mr Knight who tipped Joe off when there was a pageboy vacancy. One of Joe's favourite haunts was downstairs amongst the machinery as it was like being in the engine room of a great ship. There were three huge Lancashire

boilers, all of 20 feet in length, looked after by a team of full-time engineers and stokers. Two of the boilers were kept working at any one time with the third on standby. The hotel had its own dynamo for electricity and the lifts worked by hydraulic power.

On another floor of the hotel, a professional dancer earned his living by teaching people to dance. He had a wind-up gramophone for his lessons and needless to say if the opportunity arose, the pageboys enjoyed playing a record themselves. Nor did they neglect their dancing education because they peeped through the windows of the Winter Garden when a tea dance was being held and learnt the steps. Then round the back they went to practise their moves in time to the music from the band that could clearly be heard.

During racing fortnight the Metropole was especially busy. Many jockeys came to steam off a few pounds in the Turkish bath and some of the racing fraternity such as Vic Gunn, the bookmaker, were also to be seen there. Jim Park was another pageboy at the hotel and he started work in 1926. Jim too was a small lad and his parents thought he would make an ideal jockey. Off they went to Lewes to make enquiries but when they found out they were expected to pay £3 a week for the privilege of being an apprentice jockey from the age of fourteen for seven years, they quickly changed their minds. They could not afford it and Jim became a pageboy instead.

Lady Sackville had a suite of rooms at the Metropole and the pageboys looked forward to her visits because she was a generous tipper, sometimes giving a boy as much as 5/-. But little Jim was her favourite and she even wanted to adopt him but his parents would not allow it. When Jim was carted off to Bevendean Hospital with scarlet fever, Lady Sackville sent him baskets of fruit, grapes and eggs to speed his recovery.

Dorothy Bowden (later Mrs Sharp) began working at the Metropole in 1915. She was something of an innovation – the first lady working out front, as it were. The reason being that so many men had marched off to war it was a case of females or nothing. Dorothy was sent to a tailor in Hove to have a fetching navy blue suit made for her before she took up her duties in reception near the large revolving doors. She was only sixteen years old but was put in charge of 667 keys. She loved the work and all the interesting people she met including French actress Alice Delysia, who paced up and down moaning 'But where is my bagg-age' with the last word drawn out in a strong French accent.

On one occasion when Dorothy was working in the office, she looked up and saw a small boy pointing a gun at her. 'Hands up' he ordered. But she laughed and refused, saying she was too busy to play with him. Just then a distraught nursemaid rushed down the stairs and grabbed the little boy. 'Thank goodness I've found him' she said 'that gun belongs to his father and you know I'm afraid it's loaded.'

Dorothy left the Metropole in 1919. She could see which way the wind was blowing – men were returning home from war and expected to have their old jobs back. So when a wealthy tea-planter and his wife on leave from India,

offered her a situation, she accepted. Her first task was to pack up the lady's hats in thirty separate boxes scattered about the suite at the hotel.

Beatrice Clissold began work as a chambermaid at the Metropole in 1925 aged fourteen. The hours were long and the pay was poor. Work started at 6 a.m. and although the girls were given two hours off in the afternoon, the working day did not finish until 10 p.m. There was one half-day off a week from 3.30 p.m. to 9 p.m. and the same hours off on a Sunday – but only once a month. She earned 12/6d a week but she had to give her mother 10/- and had to buy her own uniform. This consisted of a blue dress with apron for morning wear and a black dress with white collar and cuffs and frilly apron for afternoon wear. A frilled white cap with black velvet bands completed the outfit. There were black shoes and stockings to buy as well, and there was not much left over to spend on the cinema or a small bag of sweets. She lived in at the hotel, which should have been an advantage but the food provided for the staff was dreadful.

Although guests basked in the glow of electric lights, electricity did not extend to the top of the hotel where the chambermaids had their rooms. The management issued them with two candles along with small amounts of tea, sugar and margarine. The maids were obliged to use the back stairs at all times – no lifts for them. They wore a chain around their waists to which were attached the room keys. Once Beatrice came downstairs at 6 a.m. as usual but the housekeeper noticed she had forgotten her keys and it took her a good ten minutes to climb back to the top of the hotel and collect them and naturally the time lost was deducted from her wages. Beatrice also remembered the blue girls who worked in the kitchens – so called from the blue and white dresses they wore with blue tricorn-shaped hats.

Ken Amiet started off as a pageboy in 1934 at the age of thirteen, the wages still being 5/- for a 72-hour week but the tips were good. At the time his father was head wine waiter, having worked his way up from being a commis waiter in 1912. Ken Amiet graduated to being a porter and stayed at the Metropole for the rest of his working life, retiring at the age of sixty-six in 1987. He remembered that in the early days there were 100 residents who lived in the hotel permanently, paying 28 guineas a week for full board. It was good value because they enjoyed a huge breakfast, lunch, afternoon tea and a seven-course dinner to round off the day. There was also a sea captain who liked to be comfortable between voyages and put up at the hotel accompanied by his parrot – a clever bird that could recite poetry.

One of the guests Ken looked after in 1947 was Winston Churchill who insisted on having the cream from the top of the milk to pour on his porridge. Other favourites were the actor Ralph Richardson and Jim Callaghan with whom he chatted about football. Ken also enjoyed seeing at close quarters such stars as Elizabeth Taylor, Richard Burton, Joan Collins and Barry Manilow.

One man who seemed to be a perfect gentleman but turned out to be nothing of the sort was John George Haigh, the acid bath murderer. In February 1948

Archie and Rose Henderson stayed at the Metropole. On 16 February Haigh turned up and paid the Hendersons' bill, explaining they had been called away urgently and producing a forged letter of authority from Archie Henderson. He asked that their luggage, including two golf bags, should be loaded into his car. He was so charming and plausible that Ken had no hesitation in complying with his wishes. It was not long afterwards that Haigh's urbane, smiling face was all over the newspapers. He had taken the Hendersons, one at a time, to his store room in Leopold Road, Crawley, shot them and dissolved their bodies in acid. On 6 August 1949 Haigh was hanged for the murder of Mrs Durand Deacon – one victim of the acid bath who did not disintegrate completely.

Frank Knight started work as a porter at the Metropole in the 1930s and stayed for many years. He began in 1933 working a 13-hour day, six days a week. His duties included hauling up buckets of coal for the fires and buckets of sea water so that guests could bathe their gouty feet. It cost them *6d* a time. He remembered when Marlene Dietrich stayed at the hotel and put the staff in something of a spin. At 3.30 p.m. she demanded a steak but the restaurant staff had gone and so Harold Lay, administration manager, had to roll up his sleeves and cook it.

Frank also had an experience with crime but nothing as dramatic as Haigh. Anyway in the 1960s there were two men and a girl staying at the hotel and when they left, Frank carried their luggage down for them. He thought at the time the cases were rather heavy. Then at 1 a.m. the police phoned. It appears the cases contained the proceeds of a bank robbery at Leeds – the gang were caught.

Stanley vom-Berg started work as a waiter at the Metropole in 1934. He recalled the time King Haile Selassie of Ethiopia refused to be served by any of the hotel's Italian waiters because his country had just been invaded by Italy. Stanley and his brother Walter were on opposite sides of the fence during the Second World War, as Walter stayed in Germany. He served in the German army and after being captured he was sent to Scotland as a prisoner of war. Meanwhile, Stanley served in the British Army and he too ended up in Scotland when he was sent to act as interpreter to the German prisoners of war. After the war Stanley returned to the Metropole where his future wife Elizabeth was working as a chambermaid. They did not encounter each other inside the hotel but in the ice rink at the foot of West Street. In March 1989 the couple celebrated their Golden Wedding.

It is a remarkable fact that from 1890 to 1982 the Metropole had its own printing plant and full-time printer. It was necessary because until 1975 daily menu cards were printed; then there were invitation cards, dinner dance programmes, conference luncheons, Masonic functions, weddings and bar-mitzvahs. Denis Russell was the last printer and he arrived in 1953. He had the pleasure of printing invitations to special guests to watch the coronation on the hotel's television (admittance by invitation only). When he started work,

the printing equipment was old-fashioned and consisted of a hand-fed machine – known in the trade as a 'cropper' – and a dozen cases of type. By the time he retired it was all up to date. One bonus Denis gained from his daily poring over the menus was his excellent knowledge of phrases used in French cuisine. André Simon was so impressed by the Metropole's perfectly printed menu that he sent a personal letter of congratulation to Denis. As the hours worked by a printer were somewhat elastic, Denis was sometimes called upon to do other duties. He particularly enjoyed dressing up as Father Christmas for children's parties and as Old Father Time on New Year's Eve.

Ken Lyon's musical connection with the Metropole went back a long way, as during the 1930s he used to perform in the Winter Garden. He gained experience by playing in other people's bands in the evenings, such as Jack Barnett's and Emilio Colombo's, while working in an office during the day. He did not turn professional until 1937. During the war he served in the RAF and he formed a double act with Joe 'Mr Piano' Henderson. In 1946 when he was demobbed he used his gratuity to set up his own band, which in those days usually consisted of five members. There was a pianist, a double bass, the drums, a violinist who could double on the saxophone and a saxophonist who could double on the clarinet. Versatility was the keyword and Ken was a vocalist too, crooning Bing Crosby-style. The men always wore evening dress when performing at hotels but if they were asked to do a show on the West Pier, they wore dark lounge suits. Ken Lyon's music was in the best tradition of the Palm Court orchestra. When he started out there were plenty of others offering the same type of music but by the 1980s he felt he was practically the last of the species. By this time his trio consisted of himself (often on his 100-year old double bass nicknamed Alphonse) a pianist and a violinist. They performed in the Pavilion Gardens on summer afternoons and the Metropole always booked them to play for a couple of hours on Christmas Eve, Christmas Day and Boxing Day. Once he even appeared before the Queen at the Royal Pavilion. Ken Lyon and his wife suffered a tragedy in their lives when their son Keith was murdered in May 1967. Keith was a bright, handsome lad of twelve when he was knifed on the Downs near Ovingdean. The crime has not been solved. Ken Lyon died in January 1991.

# Lifeboats and Shipwrecks in Victorian Times

Brighton first had its own lifeboat on 15 January 1825. This was not the earliest lifeboat in Sussex by any means as Newhaven, Rye, Rye Harbour, and Eastbourne already had their own. Brighton paid for its lifeboat and it was not until 1858 that the RNLI funded one for the town. The lifeboat was housed in a cave in the cliffs near the entrance to the Chain Pier.

Rescuing seamen from distressed vessels was one thing but then came the problem of how to help them once they had been brought ashore. It was nearly always the case that the men were completely destitute and often they were far away from their home ports. If the ship was laden with cargo but had foundered before reaching her destination, they could not expect any wages either. To help such men the Brighton branch of the Shipwrecked Fishermen and Mariners' Benevolent Society was formed in 1839.

The society also acted as an insurance club for local fishermen. Around seventy Brighton fishermen showed an early interest and put their names down as subscribers. But when it came to paying their dues it was a different story. The committee members could not understand it because the subscription was only 2/6d a year and should the father of a family be drowned at sea, then his wife and family would receive support from the society.

The Brighton branch had not long been in existence when it had to deal with a major emergency involving not one shipwreck but three on the same day, 13 November 1840, caused by a 'most violent hurricane'. Two of the ships were wrecked at Black Rock and the other at Portobello. The ships were all carrying cargoes of coal. They were the brig *Mary* of Sutherland (bound for Shoreham with a crew of six), the schooner *Sir John Seale* of Dartmouth (bound from Leith to Portsmouth with a crew of eight) and the brig *Offerton* of Sunderland (bound for Cowes with a crew of eight). Amazingly none of the men drowned although it

was a near thing. The night was so black that the crew of the *Sir John Seale* were unable to see the coast and so they remained lashed to the mast until daybreak. When it was light enough they managed to struggle to the shore in an exhausted state and two of them were taken to the Sussex County Hospital.

The crew of the *Offerton* were saved by the efforts of the coastguards at Black Rock. In recognition of their efforts the Shipwreck Society of London presented their gold medal to Captain Marsh and silver medals to Lieutenants Newnham, Pratt and Pryor. The drama was recorded in the Minutes of the Brighton Branch as follows;

'The sea broke most furiously against the High Cliff completely covering the Beach ... At this spot Captain Marsh with some of his men were twice lowered by ropes from the top of the Cliff to a slight ridge at imminent peril of their own lives, (and) were enabled to seize hold of the men belonging to the vessel as they were washed out of their boat which was swamped immediately afterwards.'

The Brighton Branch voted £15 towards the relief of the seaman but the Revd J. S. M. Anderson organised an impressive whip-round and came up with £95. Together with other donations the grand total came to £130 9s 10d. The money was spent on the crews while they were at Brighton and on their fares back to their home towns – twelve to Sunderland, one to Southwold in Suffolk, three to the Isle of Wight and six to Dartmouth. Then £6 was given to each captain, £4 10s to each mate, £3 10s to each seaman, and £2 for each apprentice. A gratuity of £10 was given to the Coastguard and the remaining money was donated to the hospital.

As a result of the *Offerton* crew's rescue, more attention was directed to the problem of rescue at Black Rock, where tides made access from the beach impossible at times. When that situation occurred, rescue was only possible from the cliff top. At a meeting held on 4 October 1841, Mr Johnstone produced a model of a movable cliff crane with attached cradle. This met with an enthusiastic reception and it was resolved that the parent society be approached for leave to use funds to construct such an apparatus. However, the society said it was outside their jurisdiction and the crane was adopted by the Royal Humane Society instead.

The question of the Society's precise role was to crop up more than once. For example there was the case of John Humphrey. He and some other Brighton fishermen were stationed at Plymouth in March 1840 for the mackerel fishing when they lost two fleets of nets valued at upwards of £100 because of a gale. An unknown vessel smartly picked up the nets but the men refused to return them. The fishermen were thus left virtually destitute. However, the Brighton branch refused to offer any compensation because the accident had not been accompanied by loss of life or boat. The Brighton branch was being perhaps too dogmatic; at any rate there was a letter from the parent society reminding them that there was such a thing as discretionary powers to supply relief in cases of distress.

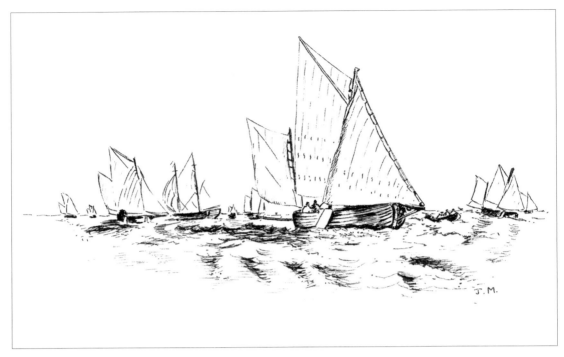

Mackerel boats coming in at Brighton in May 1830. (*E. W. Cooke*)

The Salvation Army Brass Band play during the service to bless the fishing nets at the Mackerel Fayre, 16 May 2010.

The next time Brighton fishermen were in trouble the Brighton Branch was more understanding, although hardly liberal, seeing as both men were subscribers. In 1841 John Harman's boat *John and Grace* was running for the shore when she struck the beach. A young lad was drowned and the damage to the vessel was put at £17. John Harman was awarded £4 and it was noted he had a wife and seven children. In the same year Thomas Wingham's boat *Love and Unity* was caught in a heavy gale off Hastings and overturned. The crew of two men and a boy were trapped beneath the upturned boat for a quarter of an hour. Fishermen came to the rescue by drilling holes in the bottom of the boat to allow them to breathe and they were rescued with some difficulty. The boat was towed inshore, receiving a battering in the process – damage was put at around £20 and the Brighton branch awarded Wingham £7.

## The Sea Trials of James Peake's Lifeboat

The problem of an overturned boat was of particular relevance to lifeboat people. In the 1850s there was great interest in improving the qualities of lifeboats especially with regard to self-righting. The Duke of Northumberland offered a prize of 100 guineas for the best design and such was the response that 280 models and plans were submitted. James Peake, assistant master shipwright at Her Majesty's Dockyard at Woolwich, was the winner and from his designs a new lifeboat was built. It was known as the self-righting lifeboat and became the RNLI's standard boat for many years. The design included air cases at bow and stern while the bottom of the boat was packed with cork for added buoyancy.

The sea trials were held at Brighton in February 1852 and a distinguished company gathered on the Chain Pier to watch. They included the Duke of Northumberland, Admiral Forbes and Sir George Augustus Westphal, veteran of the Battle of Trafalgar and Hove resident for many years. There were also two captains, three lieutenants, three commanders, Coastguard officers, and the Bishop of Bath and Wells, not forgetting Mr Peake who no doubt was a trifle anxious.

The new lifeboat arrived from Woolwich aboard the steamer *Monkey*. The elements decided to test the boat's sea-worthiness before the official programme began. 'On approaching the head of the pier, the boat while waiting orders to haul to the wind, under a heavy press of canvas, shipped a heavy sea which threw her on her broadside; but she immediately righted.' Next the gear was removed from the boat and the crane was used to capsize the boat twice. This crane was situated at the end of the Chain Pier and was normally used to unload luggage from the steamers. It was with great difficulty that the boat was thrown keel upwards but it 'took only 30 seconds in the first instance, and 50 in the second, to recover herself and become perfectly upright, and in two minutes she had discharged all her water.'

The Chain Pier was not just an elegant promenade over the waves – it also served as a landing stage for cross-Channel passengers and there was a crane at the end to assist with hauling up luggage.

So ended the sea trials. The boat was found to be satisfactory except for one defect common to all lifeboats of the period – she was too heavy. The trials brought some financial benefit too because £90 was subscribed towards buying and maintaining a lifeboat at Newhaven.

## The Rescue of the *Pilgrim's* Crew

In the 1850s Brighton had three lifeboats, none of which had been provided by the RNLI. They were the town boat, the Royal Humane Society's boat and a private boat owned by John Wright who also owned pleasure boats and bathing machines. All three boats took part with varying success in rescuing the crew from the coal brig *Pilgrim* that got into difficulties off Brighton in October 1857.

The lifeboats had a hard time of it; the Royal Humane Society's boat struggled for two hours to reach the *Pilgrim* and within 20 yards of the vessel, she suffered an accident and had to return to shore. Wright's boat was quick off the mark and reached the *Pilgrim* first but then shipped a heavy sea that filled the boat to the rowlocks and snatched away five oars.

This left the town boat, but first of all men had to be found to man her – since the town provided the boat but not a permanent crew. All the same the town boat managed to bring off five of the crew and then she filled with water so rapidly that both those on board and those watching anxiously on shore never thought she would make it safely to the beach. There were still three men left on board the *Pilgrim* – Wright made two more attempts and the town boat went out again but the sea was far too rough. By this time some of Wright's crew had had quite enough and deserted and Wright feared he would not be able to put out a fourth time. Then Captain Mansell of the Hove Coastguard agreed to let him have four of his men and this time the last of the crew were brought safely ashore.

The whole drama had been watched by thousands of people on the beach who cheered loudly when they saw the men being rescued but the loudest cheer was reserved for John Wright when his boat came in for the fourth and most successful time. The shipwrecked men were taken first to the Wellington Inn in Pool Valley to thaw out in front of a roaring fire, although two of them were so chilled they could not stop shaking. After a meal the men were taken to the Town Hall where they had a hot bath and a complete set of new clothes. They spent the night at the Cricketers Inn and next day went home to Portsmouth – their train fares having been paid for them and each man received a half-sovereign from Alderman Cordy Burrows.

A fund-raising effort for the shipwrecked men and their rescuers realised the sum of £267 10s 6d. Wright received £20 for the use of his boat and every man – from those who assisted in the launchings to those who had manned the oars – received some remuneration. The seventeen men who succeeded in rescuing the crew received £9 each. There were in the town boat, Nathaniel Gunn, Thomas Care, Thomas Atherall, Frederick Collins, William Measor, John Taylor and Walter Coates; in John Wright's boat, John Wright, John Wright junior, John Mover, John Spicer, James Atherall and Charles Marchant; Hove Coastguards, James Harris, George Goodman, John Gillard and James Pratt.

There is no mention of the Shipwrecked Fishermen and Mariners' Benevolent Society. Probably the local branch had folded by then, a surmise supported by the fact that the entries in the Minute Book ceased in 1844.

Three weeks after the wreck of the *Pilgrim*, a public meeting at the Town Hall considered the desirability of forming a local branch of the RNLI and stationing 'one of the Society's boats on our beach.' The following year (1858) the first RNLI boat to be stationed at Brighton arrived. She was a self-righter and she remained for nine years but there does not seem to be any record of her name – if indeed there was one.

## Launches to the Barques *Vizcaya* and *Aurora*

February 1859 was a busy month for the lifeboats. After a fierce storm a large
barque was observed, the mast gone and the vessel drifting down Channel
around four miles out. John Wright's boat was quickly launched although
there were large waves. However, the men at the Greenway Preventive Station
at Rottingdean had also spotted the vessel. Their small 4-oared galley set out
under the direction of Richard Millard, a veteran boatman. Onlookers were
anxious about the craft because it was such a small boat and there was a heavy
sea running. But the galley reached the drifting vessel before John Wright's boat
arrived. John Wright's men were surprised to find out they were not welcome.
This was because the galley's crew did not want to share their salvage prize.
The vessel had been abandoned and the only living thing on board was the
ship's cat. John Wright soon settled the argument by pointing out that the flag
of distress was still flying at the mast-head and that he had a right to come
aboard too. When both crews were on board, the distress colours were quickly
hauled down to forestall claims by any other boats in the offing.

   The drifting vessel was the Spanish barque *Vizcaya* of Bilboa, in ballast, and
she had collided with the Dutch ship *D'Elmina* laden with a general cargo of

Sir John Cordy Burrows was three
times Mayor of Brighton and this
statue of him was erected in 1878. In
1857 he presented a half-sovereign
to each of the shipwrecked *Pilgrim's*
crew.

rice, sugar, spirits and a small amount of coffee. All the *Vizcaya's* crew had been safely taken aboard the *D'Elmina* which was later taken in tow by the tug boat *Don* from Shoreham. The *Don* towed her as far as Spithead where the Portsmouth tug, which had been telegraphed for, took over the task.

Meanwhile, back at Brighton the lifeboats were returning. The scene was described thus in the *Brighton Herald*: 'It was afternoon when they were descried in the direction of the Pier, and a cry of "the lifeboats are returning" soon caused cliffs to be lined, even the carriages stopping ... The boats came bravely in, with their colours flying, amidst the shouts of the assembled spectators.'

The same newspaper carried a report of another vessel in distress, this time the barque *Aurora*, 335 tons. She was seen over a mile from Rottingdean and all three lifeboats were alerted. It was thought best to take the new lifeboat by road to Rottingdean and launch her from the beach there. But the journey was incredibly slow, taking well over two hours despite the best efforts of four horses. The lifeboat and crew were just too heavy and it was felt that eight horses would have been more realistic. Not that speed mattered too much in this case because none of the lifeboats managed to get near the vessel. John Wright's boat was out on the sea for over an hour to no avail, but early the

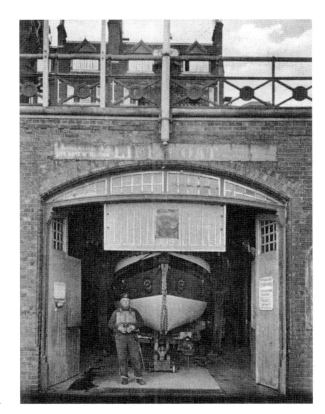

The RNLI lifeboat at rest in its home in the arches. Note the cork life-jacket the crew member wears.

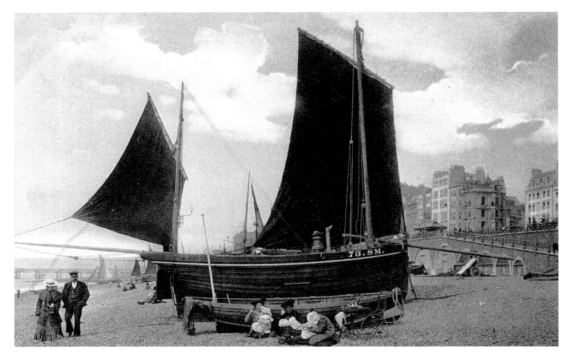

One of Brighton's stalwart fishing boats drawn up on the beach. The SM signifies that the vessel was registered at Shoreham.

next morning he reached the ship at last. On board there were Captain J. Inge and his wife who was ill with seasickness and fright, plus twelve crewmen. There was no immediate danger and so Wright's men stayed on board some hours in case they should be needed. Eventually the *Paris* came out from Newhaven to tow the *Aurora* into port and the Captain gave Wright £6 as a gratuity for himself and his men. It was stated that the danger encountered in going to the assistance of the *Aurora* was far greater than on any previous occasion on which the lifeboat had been used: 'Fifty times she was filled and as often emptied herself instantly, the only inconvenience being that the crew were drenched and drenched again to the skin.'

The contemporary newspaper accounts do not make it clear which lifeboat was which. John Wright had his own lifeboat in 1857 but he was also coxswain of the RNLI boat during the 1860s at least. The term 'John Wright's boat' in this context is ambiguous but as the boat was described as new, it might well have been the RNLI one.

On 2 June 1860 a fierce storm wrecked havoc along the coast and the RNLI boat was launched twice on the same day. First she went to the aid of the French barque *Atlantique* of Nantes, which struck the beach opposite the Albion Hotel, destroying part of the groyne. The captain and crew jumped into the sea and managed to scramble ashore except the mate who was carried away

and drowned. His body was washed up nearby around an hour later. Then the lifeboat was called out to the coal brig *Transit* of Shoreham, which had run ashore on the east side of the Chain Pier. The vessel was knocked to pieces within a few minutes leaving the beach strewn with coal and timber. Further west the collier *Pike* was wrecked on the east side of Shoreham Harbour, the schooner *Mary Ann* beached on the west side, the Brighton fishing smack *William and Eliza* ran ashore at Southwick, and the lugger *Eliza* split into pieces.

## The First *Robert Raikes*

In 1866 there was much discussion at Brighton about a new lifeboat and lifeboat house. The old lifeboat house was situated at the Middle Street Gap but the question of where to put the new one caused some controversy. Everyone agreed about the desirability of a new boathouse – it was just that nobody wanted it sited near their particular patch. Sir Francis Moon collected sixty signatures for his petition requesting that the building should not be allowed to obstruct the view of people living on the front. Various sites were discussed – the beach near the toll house on the western boundary; the appropriation of one of the sea front arches; the beach near Hove Coastguard Station. In the case of Hove, the Brunswick Square Commissioners were equally anxious not to have the building near them. In contrast to these discussions in the council chamber, the ordinary folk wanted a boathouse and petitioned for a public meeting to discuss the matter.

Furthermore the Town Council only had to find a suitable piece of land since the RNLI had offered to 'send down a most excellent boat, and to erect, at their own expense' a boathouse on the beach. This debate took place in January 1866 and it was not until June 1867 that the corporation seal was affixed to the lease of a portion of beach in front of the Bedford Hotel. Naturally the proprietors of the latter were not happy and wrote a letter to the *Brighton Gazette* complaining that the roof of the boathouse was 18 inches above the level of the esplanade; because of their objection, the council decided not to go ahead at the moment with the building of a bridge that was supposed to link the esplanade with the boathouse roof.

The new lifeboat finally arrived in autumn 1867 with a suitable ceremony both on the beach and at the Dome. The lifeboat gave a public demonstration on 1 October and although the public enjoyed the spectacle it was unfortunate that hardly any money was donated to the RNLI. A letter to this effect appeared in the *Brighton Gazette* and an appeal was made for funds with a gentle reminder that the boathouse had cost £700 and that there had been great difficulty in obtaining land.

The children of the London Sunday Schools funded the boat, which was named the *Robert Raikes* after the founder of the Sunday School movement. The children collected £580, enough for two lifeboats that served Brighton one

after the other, the first one from 1867 to 1874 and the second one from 1874 to 1888. In a parallel situation in 1877, children from the Jews' Infant School, Commercial Street, Aldgate, collected money for the Newhaven lifeboat called the *Michael Henry*. The Jewish children's total was over 400 guineas, which Miss Hannah de Rothschild presented to the RNLI. This was the first of a succession of *Michael Henrys* at Newhaven, all paid for by Jewish children.

## The Second *Robert Raikes* and the *Broughton*

The second *Robert Raikes* sprang to national prominence because of a November gale in 1875. A large engraving of the boat being launched at Brighton in heavy seas appeared in the *Illustrated London News*. The publicity carried bitter undertones too because there were certain aspects that brought recrimination from those who felt the town's honour was at stake but who did not understand the sea,

There was one indisputable fact and that was the refusal of some crew members to take their places in the lifeboat. Thomas Atherall, the coxswain, then had to launch the boat with a crew of whom two-thirds were volunteers. It was obvious the terrible storm when the *Pilgrim* foundered was still fresh in their minds although it happened eighteen years previously. In mitigation of their refusal to turn out, it was stated that these men had been driven ashore three times when attempting to reach the *Pilgrim*. But they were dismissed from the service.

There were those who felt the lifeboat was slow in being launched. But Captain Maquay, coastguard, said that considering the circumstances, the boat was launched very quickly. In December 1875 a special meeting of the Brighton Branch of the RNLI was held and H. M. Jenner, the honorary secretary, was exonerated in this respect because it was his decision when to launch the boat. The meeting came to the conclusion that he had 'exercised a wise discretion, in not launching the Life Boat on Sunday 14 November, before the tide had half ebbed, as otherwise, the result would have been in all probability, destruction to the boat, and death to her brave crew.'

Once launched, the *Robert Raikes* made her way to the *Broughton* of Liverpool, which was flying distress signals. She was laden with coal from Sunderland and she was about four miles off Brighton. Her mizzen mast had gone and her sails were blown to ribbons 'except her fore-topmast stay-sail, under which she was endeavouring to get clear of the cliff to the eastward of the town.' In less than an hour the *Robert Raikes* had rounded to under the lee of the vessel and three fruitless but gallant attempts were made to throw a line aboard. They failed and the *Robert Raikes* was swept away to leeward. It seems Tom Atherall thought the vessel was driving whereas her anchor was down and the cable held so that he overshot the mark. By this time the crew of the *Robert Raikes* were exhausted and they were obliged to make for Newhaven. Here

the bedraggled men were not received kindly according to Mr Jenner, who said he was ashamed of Newhaven people for behaving in this manner. When the weather moderated, the Newhaven harbour tug took the *Broughton* safely in tow. There was no loss of life. The poor treatment meted out to the crew of the *Robert Raikes* must have infuriated Baroness Rothschild because she invited them and their wives to a special dinner held in the Auction Room, Western Road, Hove. Tom Atherall, coxswain, occupied the vice-chair and Mr Jenner proposed a toast to the Baroness's health and said the men had done their duty and a 'braver crew never manned the boat.'

H. M. Jenner was the man at the centre of the row. He joined the committee of the Brighton Branch of the RNLI in 1871 and became honorary secretary two years later. As well as having to give an account to his local branch, he also had to answer questions at a Town Council meeting about the conduct of the crew and the management of the boat. Nor did the press remain silent about the matter and Jenner particularly resented a comment on the letter page that alleged a stigma rested upon the town. To cap it all Jenner received a snipe from an unexpected quarter when he received a letter from RNLI headquarters stating that the expenses incurred were the most extraordinary ever encountered. Jenner was so infuriated that he told his colleagues he had no option but to resign, but they hoped he would not give up his post 'in consequence of a bit of red-tapeism.' In December 1875 the RNLI made amends by resolving to present Jenner with their thanks inscribed on vellum. Jenner did not resign until March 1877.

## The Rescue of the *Ida's* Crew

In January 1877 the barque *Ida* was observed coming straight towards the West Pier but the captain managed to alter course sufficiently to avoid it. The Ida finally came to rest stranded on the beach opposite the Grand Hotel. Then she rolled over on her port side and the waves washed violently over her. Hundreds of spectators flocked to the beach 'hoping that those on board the ill-fated barque would escape with their lives, although as to this doubts were felt.' Before the vessel stranded, a rocket was fired but it fell astern of her and so the rocket frame was moved and a second rocket went across the *Ida's* fore and main masts. Unfortunately, the crew were too ignorant of this life-saving device to make use of it, added to which the crew was of mixed race and barely understood one another.

The rocket apparatus had been in use at Brighton for some time. In October 1859 experiments were carried out with Dennett's rockets and the brig *Menodora,* lent for the occasion by ship-owner Robert Horne Penney. By means of the rockets, some apparatus was fired from the Chain Pier to the *Menodora* that later enabled a man to be safely transferred from the vessel to the pier. It may have been the same make that was used for the *Ida.*

When the *Ida* was wrecked, the beach was a scene of confusion as hundreds of sightseers jostled for space alongside men attempting to move the rocket frame and fire rockets, and there were only six policemen present. In the confusion a live rocket lay forgotten on the beach and when it went off accidentally, it killed bystander E. H. Jones. There was a Board of Trade inquiry into the death but there was conflicting evidence as to whether or not the rocket's cap had been knocked off.

Meanwhile, the lifeboats had put off. They were the *Robert Raikes* under Thomas Atherall and the town boat under Fred Collins, with the crew William Bassett, John Gunn, James Gunn, S. Smith and J. Taylor. The town boat reached the wreck before the *Robert Raikes*. The *Ida* had a crew of fourteen hands and ten of them clambered into the town boat and were landed safely ashore. One had a narrow escape when he misjudged his leap into the lifeboat, fell into the sea and was nearly drawn under the vessel. Three men jumped straight into the sea and with the greatest difficulty managed to swim to the shore with the aid of lifebelts. One of these was a Negro and he was dragged unconscious from the sea. He was carried to the police station where Dr Taaffe applied restoratives and brought him round.

The wreck proved a hit with Brighton urchins who climbed all over her at low water and helped themselves to biscuits. They also discovered flour casks and pelted each other until they resembled millers. The wreckage was sold for £250.

## The *John Whittingham*

In 1879 the new Brighton lifeboat, *John Whittingham*, went on her trials but they were not altogether satisfactory because the valves would not act. The boat was so named because when Jane Whittingham died she left £300 in her will to Brighton for a lifeboat to be named after her husband. The RNLI contested the bequest in the Court of Chancery on the grounds that there was already a lifeboat at Brighton, namely the *Robert Raikes*. The town agreed to conform to the special terms of the legacy and therefore the Master of Rolls ordered the will to be executed.

In 1885 the crew of the *Robert Raikes* were John Stow (coxswain) James Asherst, John Spicer, Charles Marchant, James Atherall, James Harris, George Goodman, John Gillard and John Pratt; the crew of the *John Whittingham* were Nathaniel Gunn (coxswain) F. Collins, J. Taylor, W. Mason, J. Ashurst, T. Carr and Walter Coates. In 1885 the Dover fishing smack *Volante* was seen flying distress signals and both boats put out. The *Robert Raikes* arrived first and found the vessel so firmly grounded that all attempts to get her off were unsuccessful. As there was a rough sea and a strong wind from the south-west, the five crewmen were taken on board the lifeboat.

By this time the Lifeboat Station was in a new position opposite the Grand Hotel. In 1886 the town clerk, F. J. Tillstone, sent a letter to the local branch of the RNLI to say they had been granted a lease for the new boathouse for 1/- per annum. In 1887 Lockyer's tender of £96 for fitting up the arch was accepted and in October that same year the town council resolved the two lifeboats should have joint use of the arch and they authorised a door communication between the arches.

In February 1888 the inspector formally condemned the *Robert Raikes* and the boat together with the gear was sold off for £16 to William Beck of 123 King's Road. The *Robert Raikes* had completed fourteen years of service. By contrast the *John Whittingham* kept going for over fifty years and was put up for auction in August 1932. No bid was made at the sale but the next day she was sold by private treaty for £15. She came complete with copper tanks, four pairs of oars, fifteen cork jackets, three lifebuoys, anchor, boat hook, six coils of rope, hosepipe, rocket apparatus, carrying barrow and 4-wheeled pair-horse carriage.

## Sunlight No 2

In 1888 a new boat called *Sunlight No 2* was presented to Brighton, donated through the RNLI by Lever & Son of Warrington, the proprietors of Sunlight soap. This was the firm's second lifeboat donation to the RNLI. The year 1887 produced a remarkable upsurge in donations and in that year no less than eighty new boats were presented to the RNLI. This was most probably due to the publicity surrounding the Mersey lifeboat disaster of 1886, when two lifeboats capsized and twenty-seven men drowned. The subsequent enquiry itemised improvements and modifications that might be made to avert any repetition of such a terrible outcome.

*Sunlight No 2* was 'fitted with everything that modern science can effect to make it serviceable for saving life'. This included

water ballast fittings consisting of two tanks amidships flush with the deck; each holding about 400 lbs, which can be filled with water and emptied in the space of a minute. She has copper air cases instead of wooden ones, (as) in the *Robert Raikes*, and great self-righting power, being able to right herself with all her gear, sails set, and crew underneath – even when the anchor is fast in the ground – in the short space of half a minute.

*Sunlight No 2* was built of Honduras mahogany, she was some 35 feet in length and 7 ½ feet wide, her keel weighed 9 ½ cwt and she had ten oars double banked.

*Sunlight No 2* arrived at Brighton by train and was kept at the station for a few days until the official launching. On the day in question she was

conveyed to the foot of Cheapside and from there to the sea-front she was accompanied by a procession that included a military band and the Brighton Coastguard. At the sea-front Alderman Cox, as chairman of the local branch of the RNLI, made a speech in which he referred to the Sunlight Soap Company in 'eulogistic terms.' After more speeches, the vicar of Brighton, the Revd J. J. Hannah, conducted a short service and afterwards the Mayoress christened the new boat by breaking the bottle hung at the side. Then the coxswain Bob Collins and his crew launched the boat. 'The mayor, nothing loth to invigorate enthusiasm, got on a stand and called for cheers to be given for the boat and crew, which were lustily responded to by those present. Meanwhile the boat had glided gracefully through the water, and the jolly crew, unable any longer to restrain their feelings, threw up their hats in delight, and gave vent to cheer after cheer, which must have told well for the condition of their lungs.'

## The Barque *Vandalia*

In March 1889 the barque *Vandalia* was sailing up the Channel when she collided with a steamer, thought to be the *Duke of Buccleuch* with a 54-man crew that disappeared around this time. The *Vandalia* of 1442 tons was bound from New Jersey to London via New York with a cargo of petroleum. At the time of the accident the *Vandalia* was close-hauled and all the lights were burning brightly. The *Vandalia's* bows were stove in and an anchor from the steamer fell aboard her, killing a crewman. The crew abandoned ship and after a 'rough time of it' – seven landed at Bognor and the captain and 12 others landed at Pagham.

Meanwhile the *Vandalia* continued on her eastward drift and when she reached Shoreham, two steam tugs went out to lay by the vessel. She moved on to Brighton where she grounded around one and a half miles off West Street Gap. Then with the tide washing out her cargo, she lifted off and drifted west finally coming to rest around 800 yards from the east end of Hove sea wall. The petroleum did not create as much mess as might be expected because it was packed in stout wooden barrels and the majority remained intact.

The *Brighton Gazette* described the scene as follows.

Yesterday was a gala day on the Brighton front and thousands were watching the two tugs stripping the vessel. Barrels of oil still continued to float to the shore and all the morning the fishermen and boys were at work hauling them up. From Middle Street to the end of the Hove sea wall numerous collections of 20 to 30 barrels can be seen and men were soon marking those they had pulled out in the hope of a small salvage. The telescope men were in great requisition and in the afternoon were besieged with people who wanted to have a better view of what was being done on board.

There were many small boys on the look out for firewood and broken barrels were quickly purloined while the paperboys shouted 'Exciting scene on the Brighton front' and quickly sold their newspapers. One of the Brighton lifeboats paid a visit to the wreck by way of practice and this was an added spectacle for the sightseers. The day was very mild and it was noted that carriages and bath chairs had not been seen in such abundance since the season. But the almost festive atmosphere was marred when Mr Cook, a crewman from the pleasure yacht *Skylark*, died suddenly while helping to haul up barrels. The *Vandalia* remained on the beach for four days before she was re-floated and towed by the tugs *Stella* and *Mistletoe* to Shoreham where temporary repairs were carried out.

## Why Wasn't the Lifeboat Launched Sooner?

On 11 November 1891 there was an exceptionally violent gale. Around noon it was noised abroad that a schooner had come ashore by Portslade Gas Works. The *Ville de Napoleon* was stranded some 50 yards out and the crew were up in the rigging appealing for help. It was fortunate that the vessel carried a light cargo and was riding high. A message was sent to the Coastguard Stations at Hove and Southwick and men soon arrived with the rocket apparatus and life-saving gear. The wind was so strong that it took a while to gauge the allowance but at length a line was dropped over the vessel and 'amid the cheers of the crowd the seamen were one by one landed.' They were chilled to the marrow and their hands remained claw-shaped from clinging to the ropes for a long time. The men were taken at once to the Adur Hotel where they were made as comfortable as possible. The five crewmen were French and only knew a few words of English. Their ship was laden with barley bound for Dunkirk from Pont L'Abbé near Brest when they were blown off course by the gale.

Within an hour or so another schooner, the *John and Robert*, was seen bearing down on the same spot. She was laden with slates from Porthmadog, Wales, and bound for London with a crew of three men and a boy. It was believed that the crew of both vessels had spotted the masts of boats in Aldrington Basin and concluded that the harbour entrance was nearby. Messages were again sent off to the coastguards who had already hung out the rocket apparatus to dry and so there was a delay in returning to the scene. But the men hanging onto the rigging were so exhausted they were unable to take advantage of the rope sent over to them by a rocket. The lifeboat was called for but arrived too late because of the difficulty in finding horses to pull it along the road. At length one of the crewmen let go of the jib-boom and was washed ashore where he was seized by anxious bystanders, revived and carried off to the Adur Hotel. The next figure rolled ashore by the waves was a fourteen-year old boy but the only member of the crew to survive the ordeal was Thomas Hills, the mate. He was of the opinion that the launch of the lifeboat would have been useless

because the *John and Robert* was stranded in heavy surf with a strong onshore wind blowing. The many watchers on the shore 'underwent the agonising suspense of witnessing in sheer helplessness the drowning of fellow creatures within a stone's throw of the shore.' The captain, William Williams, aged forty-five from Carnarvon left a widow and eleven children – the twelfth child also, called William, drowned with him. The captain was the mate's uncle. The third crewmen who died was John Griffith Thomas aged seventeen from Llanwada. All three were buried in St Leonard's churchyard, Aldrington.

Naturally there was uproar over the disaster and the failure of the lifeboat to make an appearance; there were accusations of cowardice and counter allegations of neglect. The truth was the earlier arrival of the lifeboat would not have made any difference. The *Brighton Gazette* remarked, 'we can imagine what our cheaply indignant protestants and fault-finders would have had to say had a lifeboat catastrophe added to the loss of life.'

Within a fortnight an enquiry was held and on 25 November 1891 the Hon W. Chetwynd, chief inspector to the Lifeboat Institution, delivered his judgement. His report brought to light certain undercurrents and a lack of liaison between responsible people. First of all he mentioned the spirit of 'cussedness' that prevailed among the longshoremen. A prime example was the witness who declared he had seen the wreck three hours before it was heard of at the Lifeboat Station and yet he did not consider it his business to warn the officers who were just five minutes walk away. He nevertheless considered it his duty to give evidence at the inquiry.

Chetwynd's conclusions can be summarised as follows:

1) The coxswain of the Shoreham lifeboat was quite right not to attempt to cross the bar but he had shown great apathy in refusing to take the boat either up the canal or the south channel to be hauled over the beach and launched.

2) The coxswain of the Brighton lifeboat acted wrongly and in direct contravention of lifeboat regulations in not at once returning to the station and assembling his crew to take the boat to the scene when he heard of the second wreck. Instead he had proceeded to the wreck on his own.

3) There was a delay in sending a boat because no horses could be obtained to pull the boat carriage. She was therefore heaved along by manpower until she reached Hove when some of the volunteers became so fed up they refused to go any further.

4) Arrangements should be made at once with owners of suitable heavy horses so that they could be hired when needed.

5) There were crowds of people witnessing the scene within yards of the Lifeboat House and yet not one of them made sure the lifeboat was actually on its way.

6) Except for two men, the late crew had left the boat when the coxswain resigned and this was a good opportunity to enrol a double crew so that the situation would not arise again.

7) All possible steps must be taken to ensure close co-operation between the coastguards and Lifeboat Station.

8) The Hon Secretary had taken office under difficult circumstances and worked zealously and prudently.

One of the recommendations was acted upon quickly and that was the question of horses. On 8 December it was recorded in the Minutes that an agreement had been reached with Stapleton & Wooley to 'horse the boat' for 10/- per man and horse. This met with general approval and the *Brighton Gazette* had already commented that it 'monstrous to expect a crew to exhaust themselves before starting a perilous mission ... in dragging a cumbersome vessel along the coast.'

The question of hauling heavy lifeboats about on land, raised the idea of stationing a lifeboat at Hove. At the close of the enquiry a gentleman handed in £500 for this express purpose. Joseph Ewart, Mayor of Brighton, wrote a letter to the Hove Commissioners stating the money was 'the free and generous gift of Mr William Wallis of 2 East Street, Brighton, to the Hove Commissioners on condition that it be used for the placing of a Lifeboat in Hove, bearing the name of William Wallis.' While the Commissioners deliberated, the money was placed in the Union Bank.

A sub-committee was formed to report back on the question of a lifeboat. They certainly looked the gift horse in the mouth and came to the conclusion it was not worth the trouble. If the £500 were accepted, they would have to raise the balance to purchase the boat, maintain a crew and build a boathouse. They estimated the average cost of a lifeboat with equipment was £700, the boathouse would cost £350 and the annual cost of maintaining a Lifeboat Station was put at around £70. As there was a lifeboat at Brighton and another at Shoreham, which had recently been ordered to a new station outside the harbour, the sub-committee did not think Hove needed a lifeboat. Mr Wallis was of course thanked profusely but his kind offer was declined.

However, Mr Wallis did have a lifeboat named after him eventually. This was the new RNLI boat that came on the Brighton station in 1904. Mr Wallis made an adjustment to his will, leaving £1,000 for the boat instead of the £500 offered to Hove. The *William Wallis* was a 35-foot self-righting boat, soundly constructed of Canadian elm and English oak and rowing ten oars double banked. The boat and carriage weighed 7 tons 8 cwt. She turned out to be by far the busiest of the Brighton lifeboats, being launched on some twenty-three occasions and she lasted until station closed on 7 July 1931. On 23 September 1931 the *William Wallis* was sold by auction to Captain A. W. R. Trusler of Southwick. The paragraph in the local press reporting the sale was headed 'Cost £1,700, sold for £35.'

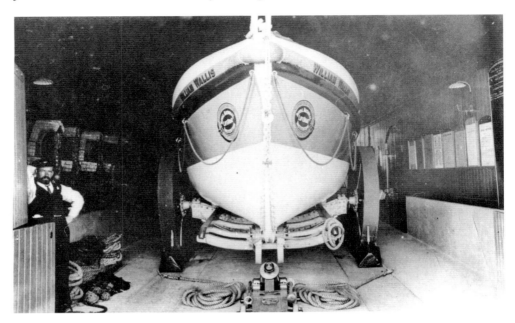

Lifeboat *William Wallis* is pictured in 1904. She served until the Lifeboat Station closed in 1931. (*Robert Jeeves*)

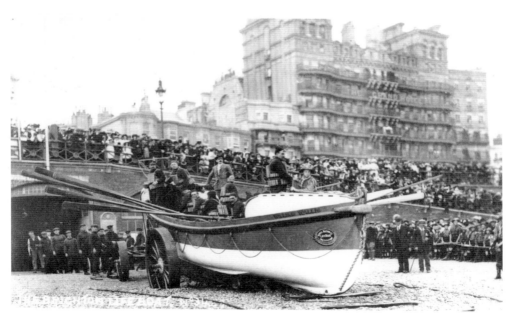

Another view of the *William Wallis*, a 35-foot self-righting lifeboat constructed of Canadian elm and English oak with ten oars double-banked. (*Robert Jeeves*)

## Some of the Lifeboat Characters

The story of the lifeboats at Brighton in Victorian times would not be complete without a word or two concerning some of the men who formed the crews. On the whole it seems they were an independent-minded lot even to the point of refusing to man the boat if, in their opinion, the conditions were too dangerous. But then they had a right to their views since most of the men were drawn from fishermen with first hand knowledge of their stretch of coast.

One of the best known Brighton fishing families were the Gunns, the most redoubtable being old Martha Gunn, the famous bathing attendant. In 1857 Nathaniel Gunn was one of the town boat's crew while in 1885 there was a Nathaniel Gunn aboard the *John Whittingham*. Another Gunn connected with life-saving was Richard Gunn, described as the 'Humane Society's man' when in 1861 he rescued two swimmers from drowning. Henry Lean, one of the grateful two, presented Gunn with 5/- for his trouble.

Another familiar surname was Atherall. James Atherall took part in the rescue of the *Pilgrim's* crew in 1857 aboard John Wright's boat. In 1868 when he was coxswain of the RNLI boat, he was dismissed for drunkenness but he was reinstated two years later. In the launch to help the smack *Volante* in 1885 the *Robert Raikes* included a James Atherall among the crew. In 1857 Thomas Atherall was aboard the town boat in the *Pilgrim* rescue and in 1875 he was coxswain and trying to whip up volunteers to crew the *Robert Raikes* when the majority of the regular men refused to serve. In 1878 he resigned after 'incivility to the inspector.'

However, the most colourful crewman was Fred Collins – later universally known as Captain Collins. Indeed he became such a well-known character that a gentleman once posted a letter in China addressed to Captain Collins, Brighton, and it reached him.

Captain Collins's name was inseparable from that of the *Skylark*, his pleasure boat, which was a feature of Brighton beach for so many years. Many holiday memories must include a trip aboard the *Skylark*. In fact Captain Collins claimed to have taken over one million people for a 'jolly sail' and not one of them was ever involved in an accident. Captain Collins was associated with the *Skylark* for over fifty years although this was not a single vessel but rather a succession, each bearing the same name.

The first one made her appearance in 1852 when it was recorded that 'a new pleasure yacht the *Skylark* arrived off Regency Square.' George Tutt of Hastings built the *Skylark* and the 'skill and workmanship reflect great credit on the builder.' Mr Nabbs of Hastings supplied the sails and the rigging was said to be similar to the America clipper schooner, except for the foretopmast.

During the 1860s Fred Collins served as second coxswain to John Wright in the RNLI boat but in March 1870 an abrupt note states he was discharged for refusing to do his duty. However that was not the end of his association with lifeboats because in 1877 he was in charge of the town boat and going to the

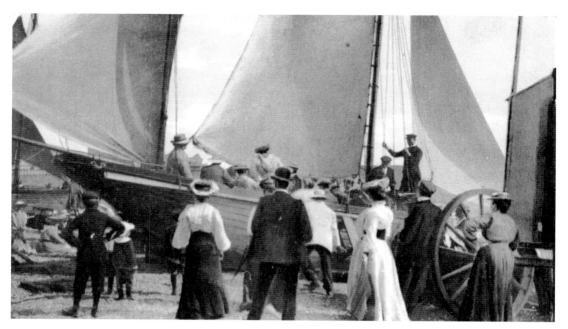

The *Skylark* prepares for a 'jolly sail' in 1907.

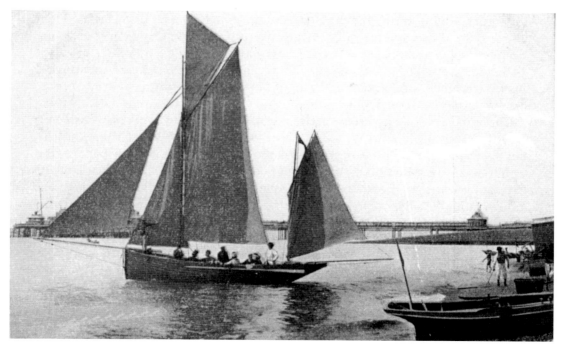

No seasickness on this trip – the *Skylark* sailing on calm waters with Captain Collins standing.

rescue of the crew of the barque *Ida*. In 1890 the coxswain of the RNLI boat was Robert Collins, Fred Collins's nephew but he too was soon discharged.

Captain Collins also kept a beer house on the beach called the Welcome Brothers. On 25 July 1877 an incident occurred that had serious consequences for him. His son, Frederick Poste Collins, was behind the bar and the Captain was upstairs when boat builder George Winder came in for a drink. He placed half a crown on the counter but there was a dispute about the amount of change he was owed. Winder moved behind the counter and there was a scuffle. At that moment the Captain came downstairs, saw the commotion and probably concluded Winder was after the till. He lifted Winder up and flung him back over the counter. There was a brief fight in which all three were involved. Four days later George Winder died and Captain Collins and his son found themselves charged with manslaughter.

The case was held in no 1 court at Lewes Spring Assizes in 1878. Lord Chief Justice Cockburn was the judge – a man of eminence who, four years previously had presided over the celebrated Tichbourne case at Westminster Hall. The prosecution produced witnesses who had seen Winder's dreadful injuries but these injuries were not confirmed by the post mortem carried out by H. Neale Smith, house surgeon at the Sussex County Hospital. But he did say death was due to inflammation of the brain and in his opinion it was a direct result of the violence suffered. He did concede that Winder had a thin skull and inflammation could have arisen spontaneously.

Mr Grantham, for the defence, said the case was a very serious matter 'for the present and future position of Captain Collins. Probably many knew him as owner of the pleasure yachts in Brighton for a great many years, and until this arose there had not been a breath of suspicion against his character, and his kindness was well known.'

Lord Chief Justice Cockburn summed up the case for the jury by saying there were two questions they must answer – was Collins guilty of excessive violence and if he was guilty, did Winder's death arise from it? They must be able to connect the cause of death with the action of Collins, bearing in mind that the fight occurred on Saturday night and Winder did not die until Wednesday. The jury did not even leave the box and returned a not guilty verdict at once. His Lordship had a few parting words to say to Captain Collins and he hoped the case would be a warning to him. He had no doubt there was provocation but in future he must take care and not let his passions get the better of him.

It would be interesting to know how the publicity affected trade at the Welcome Brothers, or for that matter trips aboard the *Skylark*. The 1885 Directory carried an advertisement for Captain Collins's fast sailing yachts with the advice that the *Skylark* sailed daily from opposite the Coastguard Station, King's Road at 11 a.m. and 3 p.m., weather permitting. The fare was 1/- per person but some years later the charge was lowered to around 9d.

In October Captain Collins made an annual trip for the benefit of some local charity such as the Sussex County Hospital. In 1890 the *Brighton Herald* told

Captain Collins wearing his customary rig including his dark hard-glazed straw boater.

its readers that here was an opportunity to help the hospital as well as enjoying a sail in the Channel. It was because of these benefactions that Captain Collins was made a governor of the hospital, a distinction of which he was proud. He carried his interest through to the end by taking a modern stand and requesting that any money that might have been spent on wreaths at his funeral, should be donated to the hospital instead.

When not engaged in pleasure trips the crew of the *Skylark* were willing to help in emergencies. For example in 1895 they were to the fore when the barque *Brockley Castle* became stranded on a sand bar over a mile from the shore and midway between the piers. The two lifeboats and the coastguard galley also put out to investigate. There was nothing drastically wrong with the *Brockley Castle* although she had been knocked about by severe easterly winds. Hundreds of spectators on the beach thought the crew had been overcome with cold, they were in fact all under the influence of drink, including the captain. However, around midday the barque lifted off the sand bar and continued her voyage.

Captain Collins was an impressive figure in the old style of dress he affected. The following description sums him up.

No one else wore a hat like that – a black hard-glazed straw, not broad in the brim, perched on the head at a slight angle. No one else, since our grandfathers, wore that stout black stock tied round his neck. The white coat was not so unusual. But this, combined with the stock and the hat, and worn by a face

and figure of such generous proportions, so florid, so full of character, made up a personality as picturesque as it was unique.

It must be said that he had a rather stern expression enhanced by long bushy sideboards that turned white as he grew older although his hair was still dark.

Captain Collins passed some sixty years around Brighton beach but he lived latterly at Barcombe and travelled to and fro daily. The house was noticeable on account of a huge flagstaff. It was at this house that he died in August 1912 just short of his eightieth birthday. There is an old mariner's superstition that death comes easier with the ebb tide and it was fitting that Collins, who was often compared with Peggotty in *David Copperfield*, should, like him, die when the tide was on the ebb.

His funeral was a splendid occasion. The coffin travelled by train from Barcombe to Brighton where it was transferred to a carriage and draped with the Blue Peter – the flag hoisted when a ship puts out to sea. Four black horses with black plumes on their heads drew the carriage, which made its way to the sea-front. The newspaper described the scene thus.

> Poor *Skylark*. Her flags were at half-mast, and though the sun was shining and the sea was calling, there was no trip for her today. The Captain was being brought to her; but he must go away again. The stately sad procession halted on the Front and came to attention. The Captain was saying farewell to his ship. The bereaved *Skylark* fluttered her flags in farewell. The crew, seafaring men in blue jerseys, with grave tanned faces, removed their caps.

The *Skylark* in question was a youngster, having been christened by the Mayor in December 1911. The funeral service at St Peter's Church was well attended and Attree & Kent had ordered 300 service sheets to be printed. Probably because of the extra work involved, the verger received 4/6d in addition to his usual fee while the organist and choir were paid £2 12s 6d. After the service the coffin was carried to the graveside by the *Skylark's* crew. They were John Rolf, Thomas Gunn, Thomas Harman, Richard Salvage, Adam Taylor, Richard Kennard, John Rudwick, George Priest, J. Redman and George Collings, engineer.

# The Vallance Family

## The Vallance Surname

There was a tradition in the Vallance family that they were descended from the de Valences, Earls of Pembroke. It is difficult to say whether this was a family myth or if there was some truth in it. The family seals John Brooker Vallance possessed were perhaps the only evidence and they had passed down the family for at least 200 years. One was described thus, 'a barry argent et azure within an orle martlets gules – the martlets being the Pembroke arms in the 13th century'.

The most notable member of the de Valences was Aymer de Valence, Earl of Pembroke (1275-1324) who was the third son of William de Valence, Henry III's half-brother. Aymer's grandmother was Isabella of Angoulême, widow of King John. Aymer also belonged to the important Lusignan family of France and he owned land there as well as in England, Wales and Ireland. Aymer was involved in matters of state throughout his life and served both Edward I and Edward II. Aymer was present at the battle of Bannockburn in 1314 when Robert I of Scotland won a decisive victory against the English. When defeat seemed certain, Aymer seized the king's bridle and led him away against his will. Aymer's personal retinue suffered severe casualties trying to cover the king's retreat.

Aymer died suddenly in France on 23 June 1324. It is sometimes alleged he was poisoned and one historian with a taste for drama declaimed he was 'murdered suddenly on a privy seat.' But it seems he died of natural causes in the arms of his servants. Unhappily for his relatives there was no time to make a deathbed confession, a serious omission in those days. Perhaps that was one reason his widow caused a magnificent tomb surmounted by his effigy to be

erected in Westminster Abbey, together with a chantry chapel where prayers might be said for his soul. In his memory she also founded Pembroke Collage, Cambridge in 1347. Aymar was twice married but there were no children, although he did have an illegitimate son.

## The Sussex Vallances

The story of the Sussex Vallances begins in 1699 when Thomas Valence of Maresfield and Fletching, heir-at-law to John Awcock of Oldlands in Fletching, Sussex, married Mary Wilkinson. Indeed this marriage document was the oldest item still in possession of the Vallances in the late nineteenth century, along with a whole mass of other important deeds stored in an old chest at Hove Manor. James Vallance was born in 1700. His brothers were Thomas who lived at Hurstpierpoint, William who lived at Portslade and David who lived at Brighton. There were two sisters, Mary and Margaret.

Not much is known about James's life apart from a romantic entanglement. He fell in love with Esther, the second daughter of the Revd John Gray, rector of Southwick. It is fair to assume that the reverend gentleman opposed the match – perhaps he did not think James Vallance was a suitable candidate or perhaps she was a good housekeeper and he was unwilling to lose her (her mother had died three months after Esther was born). Whatever the reasons the couple thought the only way to be married was to elope. Her father never quite got over it and referred to his daughter in the Southwick parish registers as the 'reputed wife' of James – however her memorial tablet states she was a wife plain enough. The fact that her children's births were registered at Southwick rather than miles away must mean there was a reconciliation of sorts although at one time her father did cut her out of his will. In the event she died before he did – on 4 March 1747 when she was only forty years old. She was buried at Southwick and her memorial is still to be seen (with difficulty) affixed to a wall behind the vestry curtain in the church of St Michael and All Angels. James and Esther Vallance had five children, John, Esther, Richard, William and Frances. James married a second time and his wife's name was Mary. James died in 1772 and Mary died in 1773 and was buried at Hove.

John Vallance (*c.*1732-1794) the eldest son, was around fifteen years old when his mother died. John Vallance married Deborah Mighel at St Nicholas's Church, Brighton on 29 September 1756. The next year their eldest child Ann was born. Four more children followed, all of them attaining maturity. They were John (baptised 1759) Philip (baptised 1761) Esther (baptised 1764) and James (baptised 1766). It seems probable that the family was living at Patcham because all five children were baptised there. However, by the 1780s the family had removed to Hove, a fact testified to by a contemporary record dated 24 July 1787 that refers to John Vallance, the elder, of Hove. The 'elder' was no

The Manor House, Hove Street.

Hove Manor, regrettably demolished in 1936.

doubt used because his son John had entered business by then and to avoid confusion between them.

John Vallance the elder is reputed to be responsible for the building of Hove Manor sometime between 1785 and 1796 but as he died in 1794, the earlier date seems more likely. He also owned land at Southwick and some of it was close to the coast because part of it was flooded with seawater. He claimed compensation from the Shoreham Harbour Commissioners who were responsible for the upkeep of dams and sluices and they admitted liability. In 1781 he was awarded 25/- a year for the loss of tithes on 3 roods and 3 rods of land and in 1787 he was paid £85 for the loss of an acre.

As for his land at Hove, he had purchased some from the Revd Henry Michell (vicar of Brighton from 1774 to 1789 and whose grandson was the redoubtable

H. M. Wagner). Vallance also bought land from a bankrupt named Aaron Winton and from Solomon Greentree. John Vallance's will stipulated that all his Hove lands should go to his wife Deborah and thence to his eldest son John who was responsible for making sure that his brothers and sisters each received £700 from the estate. The younger John Vallance was not allowed to drag his heels in the matter because if his siblings had not received their money within six months, the will was to be declared null and void and the inheritance would go to his brother Philip instead.

On 4 June 1789 John's brother Philip Vallance married Maria Fayres-Killick at St Nicholas's Church, Brighton. The Killicks probably already owned the West Street Brewery established in 1767. It was one of the oldest in Brighton and with this marriage the three Vallance brothers became associated with it too.

It is interesting to note that the three Vallance brothers were non-conformists by conviction although they had, by necessity, to be married according to the rites of the Church of England. They favoured the church in North Street, Brighton known as the Countess of Huntingdon's Connexion. From Philip's family of seven children, six were baptised there; from James's family of seven children, four were baptised there and John's eldest child Ann was baptised there too. But John later moved his allegiance to Union Church in the Lanes, of which he was a deacon. He allowed a group from the Union Church to use an outhouse of his at Hove in which to hold prayer meetings and Sunday School. This concession was not renewed when he died in 1833 and eventually the group managed to raise enough money to buy some land in Hove and build the Congregational Church in Ventnor Villas. One of James's sons George Vallance had four of his six children baptised at the Union Church in Union Street. But in death John Vallance returned to the Church of England.

John and Philip Vallance were keen cricketers and were members of the team in the great match that took place on the Level at Brighton in August 1790. The match lasted two days and one of the spectators was the Prince of Wales (later George IV). Brighton lost to Wadhurst by two wickets and this was in spite of having the notable Hammond on the Brighton side. However, in a return match a week later, Brighton won by five wickets. In 1792 Philip scored 33 runs in the Brighton *v.* Hampshire match and two weeks later in the Brighton *v.* the Gentlemen of Marylebone match, Philip had the dubious honour of being caught out by Earl Winchelsea. John scored four not out in this match. The match of the season between Brighton and Middlesex took place in August 1792. Amongst the spectators were Mrs Fitzherbert and the Duchess of Noailles. Unfortunately, such fine company did not inspire the Vallances – John was out for a duck and Philip was run out for one. It is interesting to note that in 1852 the firm of Vallance & Catt purchased the lease of the Brunswick Cricket Ground in Hove – the forerunner of the Sussex County Cricket Ground.

It may be that John Vallance and the Prince of Wales became acquainted through their mutual love of cricket. In any case the Prince stayed at Hove Manor House while work was being carried out at the Royal Pavilion and

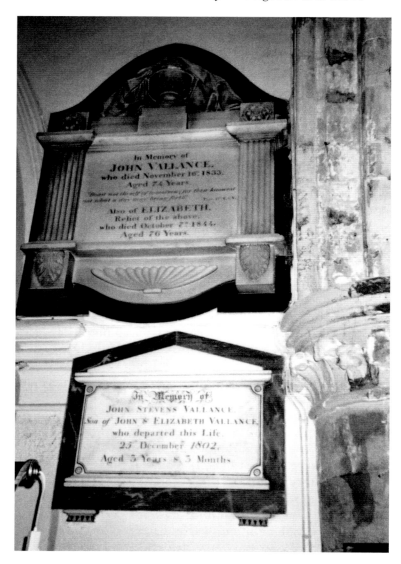

Vallance Memorials
inside St Andrew's
Old Church, Hove.

when he left he presented John with an engraved punch bowl, which became a family heirloom.

On 4 January 1794 John Vallance married Elizabeth Stephens at Lewes and the following year their first child Ann was born. The next child was John Stevens Vallance born in 1799. It was a family tragedy when the child died on Christmas Day 1802 aged three years and three months. It was also unusual because the Vallances had a good record of raising their children to maturity. The third and last child was John Brooker Vallance who was born in 1804. John Vallance died in 1833 and was buried in a vault at St Andrew's Old Church, Hove – the ledger stone is still visible near the lectern.

## John Vallance, Inventor, and Two Brothers

In this plethora of John Vallances there is yet another one to muddy the waters. This John Vallance was born in 1790 and was the eldest son of Philip and Maria. He was an inventor and took out three patents to do with improvements in brewing, one for ventilating rooms and another for a method of freezing water. But his most famous patent (4905) taken out in 1824 was for an atmospheric railway, the first of its kind. A successful experimental line was constructed in 1826 but his ideas were not taken up and it was left to future generations to admire his ingenuity. The prospect of people being shot along a tube was a novel one and wags dubbed it 'Vallance's Suffocation Scheme.' He invented a form of suspension where each wheel was attached to a piston in a small pneumatic cylinder supplied with compressed air. But his vision was limited by the technology of the day. For example the cylinder in which the carriage was to travel was to be cast-iron, bolted together with hoops, then coated in thick flannel well soaked in melted tallow. Then again the space between the carriage and the tube was to be sealed with bear's fur or any other skin with long, thick hair. He died suddenly in 1849 at his lodgings in Western Road, Hove.

John's brother Benjamin, born in around 1808, was the youngest son and took no interest in the family brewery. Instead he took up medicine and became the first house surgeon at the Sussex County Hospital when it opened in 1828. His brother Philip used to visit him at the hospital and he had a scientific turn of mind too. He was much interested in electricity and had constructed a machine of 'some little power.' One day at the hospital, he carried a wire from this machine to the door handle of the students' room nearby intending to give Mr Gwyn a small shock. But his practical joke backfired. When Philip heard a noise, he rushed out to discover the Revd James Anderson, chaplain to the hospital and chaplain-in-ordinary to Queen Adelaide 'in his surplice, flat on his back.' On hearing Philip's explanation, the unfortunate clergyman's only comment was 'It need not have been so strong, even for Mr Gwyn.'

On 21 September 1852 Lady Jane Peel laid the foundation stone of the east and west wings of the hospital and it was a great social event culminating in a dance. But young Nathaniel Paine Blaker was too busy revising for his medical exam to participate. He worked in a room next to the old Vallance Ward that doubled as a students' sitting room as well as a casualty room. After supper had arrived at 9 p.m. (bread, cheese and beer) a Pyecombe woman was brought in, a railway engine having crushed both legs. Surgeons were sent for, supper was hastily cleared away and put in a cupboard, the table was moved to the centre of the room and a mattress placed upon it; the instruments were laid out on the windowsill and three bull's-eye lamps were lighted. Then Benjamin Vallance amputated both legs 'very well,' one above the knee and the other below. The patient was removed, the instruments washed, the table swabbed down and supper was again laid upon it. It is not clear if the poor woman survived. Amputations were sometimes carried out without anaesthetic and if

the shock did not kill the patient, infection was always lurking especially as the same sponge was used to wash amputees, one after the other.

## Vallance & Catt, Brewers

Meanwhile the brewery continued to prosper. The firm also owned premises at the Rock, Southwick, that were liable to damage from the sea. In 1797 Killick and Vallance had to expend £149 3s 2d in erecting some sort of sea defence to protect their warehouses. Fortunately they were able to claim £100 back from the Shoreham Harbour Commissioners. In 1798 there was further damage and in that same year, the Killick name bowed out of the firm, which was now run by the three Vallance brothers.

It appears that the Vallances were forward looking in their use of new technology and their brewery was an early user of steam. In 1807 Woolf's Patent Steam Engine powered the machinery. Then of course there were the patents taken out for various improvements in the brewery business.

James Vallance married Ann Catt at Lewes in 1790 and the couple had six sons and a daughter. James and Ann sat for their portraits in around 1840 and they look like a very sober, country couple and not at all as you would imagine a brewer to be. They lived at Kingsland, Hurstpierpoint, a large manor house set in an estate of 90 acres. The brewery continued as a family concern known as Vallance & Sons. James seems to have retired in the 1820s when William Catt became involved with the brewery and James died *c.* 1847. But two of his sons Edmund and James remained. When Edmund died in 1855 he left a farm called Lofield or Lovel near Cuckfield to his wife Mary Alice and all his books to his daughter Mary Gertrude.

Out of James' other sons Charles decamped to Bristol where he established his own brewery although his son was born at Bath in 1841; Henry tried his hand at farming in West Grinstead but it did not suit him and both he and his brother George, a solicitor, went to join Charles in the West Country. However, it seems that Charles was back in Brighton by 1851 when he purchased some shares in the ship *Sarah Bell* and was described as a Brighton brewer and later on, as a ship-owner. Charles Vallance and his wife Hannah lived at Belgrave House, Preston. In July 1881 their eldest son, also called Charles, of 33 Buckingham Place, died at the age of forty-three. His father followed him less than three months later at the age of eighty and Hannah died in February 1882 aged eighty-one. They were buried in Brighton extra-mural cemetery.

William Catt (who was the brother of Ann, wife of James Vallance) married Elizabeth Hammond of Waldron in 1796. He was the dynamic young man who leased Bishopstone Tidemills from 1801 when there were just five pairs of millstones. But under his direction the place reached a peak of prosperity until there were sixteen pairs of millstones. It was William Catt, junior, who was associated with the West Street brewery. As he had the same name as his father

James Vallance (1766-1847) painted in around 1840. (*Hove Museum*)

Ann Vallance (née Catt, baptised in 1765) painted in around 1840. (*Hove Museum*)

he had to put up with being styled 'junior' even up to the day of his retirement, which occurred in 1843. To mark the occasion he gave a farewell dinner at the Bull Inn, Ditchling with good food and wine and much singing and music. The Catt connection continued with Charles and Henry Catt working for the brewery. Charles Catt was the fifth son of William Catt of Bishopstone, and he lived for many years at 44 Middle Street, Brighton. Later on he had a country residence called Summer Hill at Lindfield. He was said to be 'always extremely exact, punctual and precise in all his dealings.' He died aged sixty-eight on 2 September 1885 at Lindfield and was buried in the family vault at Brighton extra-mural cemetery. He was the older brother of Henry who now became head of the firm.

Henry Catt is of particular interest because in 1863 he changed his surname to Willett in order to benefit from the will of his eldest sister Elizabeth Catt. She hated her surname and insisted that all beneficiaries must change to being a Willett – her grandmother's maiden name. The name Henry Willett is well known today because of the ceramic collection amounting to over 1,000 items he donated to Brighton Art Gallery and Museum.

With the advent of the Catts, the brewery became known as Vallance & Catt and continued to use the name until the 1890s long after the Vallances had ceased to have a connection. In 1855 Vallance & Catt were advertising the fact they could supply 'their celebrated ales, stout and porter in jars of 1, 2, 3 & 4 gallons, wicker cased and with brass lock taps.'

Vallance & Catt owned an incredible number of pubs in the local area – something in the region of seventy. Amongst the best known were the King & Queen, Seven Stars, Cricketers, and White Lion (all in Brighton) Brunswick Hotel, Ship Inn, and Eclipse (all in Hove) and the Mariner's Arms Inn in Southwick. But it seems they were benevolent employers and their Christmas list for 1852 included 200 prime turkeys to be presented to each inn keeper and beer seller connected with the firm. In addition vouchers were issued to every man in their employment enabling him to draw beef and beer proportionate to the size of his family.

Another Vallance & Catt tradition was the annual outing for their employees, which by 1884 had been going for fifty-three years. The maiden trip was to Seaford; the one in 1884 was to Burgess Hill where dinner was served in a specially erected marquee adjacent to the Burgess Hill Inn. An arrangement was made with the railway company to transport everybody there and back. The press report stated that it was one of their most successful outings 'given by this old-established firm, noted for its liberality.'

During the course of the nineteenth century Vallance & Catt began to diversify and became coal merchants and general dealers as well as brewers. The coal business was run from 8 West Street – the same address as the brewery while their stores were at 14 West Street. By 1884 they could boast of being coal merchants to Her Majesty Queen Victoria and sold 'Wallsend and Inland Coals of the Best Quality only.'

The schooner *Kingston*, launched in 1838.

The *Princess Royal*, registered in 1841, was one of the first screw steamers in the area and was owned by a consortium of local businessmen.

It was a logical step therefore that they should come to own ship shares. The first in 1824 was a square-rigger named *Alice* owned by James and Edmund Vallance. The schooner *Kingston*, owned by William Catt, is of interest because it was the first vessel to be launched from May & Thwaites' Kingston yard in 1838. Another vessel of note was the *Princess Royal* registered in 1841, one of the first screw steamers in the area. A consortium of local businessmen owned her and nobody had more than four shares each. Amongst their number were Edmund Vallance and both William Catts. It is interesting to find that the Catts owned shares in two vessels built in Prince Edward Island, Canada. They were the square-rigger *Elizabeth* and the brigantine *James Douse*. Such vessels came from the cheaper end of the market and were especially popular with owners engaged in the coal trade.

Altogether the Vallances and Catts owned shares in twenty different vessels. Some of them carried coal but the square-rigger *Eliza Jane* and the *Daring* brought timber from Archangel to Shoreham. In 1874 the *Daring* was endeavouring to enter Shoreham Harbour when she grounded on the shingle accumulation near the middle pier. As the licensed pilot was in charge at the time, Vallance & Catt felt justified in claiming £349 in damages – the harbour authorities refused to pay up. The last ship was the brig *Mariner* registered in 1871 and in which Charles Catt owned twenty-eight shares. (Ship shares were calculated at sixty-four shares a vessel. For a full list of their ships, see appendix).

There is one more fascinating story to relate about the brewing Vallances. During the First World War Sergeant R. W. Hughes of Glenside of Wish Road, Hove, made a remarkable find in a German dug-out. Among the German books there was an old English one called *Incidents in an Eventful Life* and was the autobiography of someone who left England for Tasmania in 1826. The author wrote 'I sailed with a young man named Vallance with whom I formed a friendship ... we got to the end of our journey in due time, and after a few months my friend Vallance took passage back to England. Afterwards I learned that the vessel was taken by pirates and all on board were made to walk the plank and were drowned.' Later on the author was standing at the window of his Brighton lodgings when a dray passed by marked 'Vallance & Co, Brewers.' He determined to find out if the dead Vallance, who he knew came from Brighton and whose friends were brewers, had any connection with the firm. He went to see old Mr Vallance, who was upwards of seventy, at West Street, and was told that the drowned Vallance was his brother.

## The Hove Vallances

To return to the Hove Vallances – John Brooker Vallance was the second son and third child of John and Elizabeth Vallance and he was born in 1804. His second name derived from his aunt Esther who married Henry Brooker at St Peter's Church, Preston, in 1785. Henry Brooker was an attorney, or a solicitor

John Brooker Vallance (1804-
1851) painted in around 1850.
(*Hove Museum*)

Sarah Duke Vallance (née
Olliver, 1811-1890) painted in
around 1850. (*Hove Museum*)

Sarah Duke Vallance, a widow for thirty-nine years. Note the typical Victorian hairstyle with the hair drawn down smoothly to cover the ears, then put up at the back and decorated with small plaits and ribbons. (*Hove Library*)

Sarah Duke Vallance photographed in her outdoor clothes with a warm muff and a bonnet tied under her chin with broad ribbons. (*Hove Library*)

in modern parlance. He may have been John's godfather. As John Brooker's elder brother had died in infancy, he inherited the Vallance land at Hove, which in 1839 was recorded as being 115 acres. This included Hove Manor and other properties in Hove Street such as the malt house, eight houses, seven cottages, among other properties, including one on the beach. But according to the 1851 census he only employed 3 servants in his house.

J. B. Vallance's great enthusiasm was for hare coursing. He founded the Brighton Harriers which met three times weekly at various points on the Downs in the 1830s. The Brighton Harriers wore dark green hunting jackets and it is probable he chose to be painted wearing it when he posed for his portrait. A companion piece is the portrait of his wife Sarah much adorned with muslin frills and jewellery, including gold chains, a jet brooch and a gold, jet and diamond ring. She has a rather strong face, brown hair, and brown eyes, while his eyes were blue. The couple had two sons. J. B. Vallance seems like a typical sportsman, hale and hearty, but looks obviously belie the reality because he died at the age of forty-seven on Christmas Day 1851, oddly enough the same date as his young brother died all those years ago. It must have been a happy marriage because the memorial inscription inside St Andrew's Old Church, Hove, runs 'This monument was erected by his widow as a tribute of affectionate regard to one who was a kind husband, a tender father and sincere friend.' His widow survived him by thirty-nine years.

When he died, J. B. Vallance left two small sons – four year-old John Olliver Vallance (the Olliver being his mother's maiden name) and three year-old William Henry Vallance. The latter died when he was twelve years old, thus leaving John Olliver to enjoy his mother's undivided attention. Looking at her face one cannot help feeling this must have been somewhat suffocating as he grew up. At least he had the society of other boys for he received his education at Brighton College – founded in 1845 as a Public School for the sons of gentlemen.

Not far from his home in Hove Street there was a small private school called Seafield House run by Erasmus G. Livesay. Young John fell in love with Emma Kate, Mr Livesay's second daughter. In the 1861 census she was recorded as being fourteen years old and she had a sister and three brothers. There were twenty-one boy pupils at the school. Reading between the lines it appears Mrs Vallance was not happy with the match. Perhaps it was because she had pretensions to gentility while Mr Livesay was obliged to earn a living as a schoolmaster. At any rate the Vallance marriage was a very low-key affair with a brief mention in the births, marriages and deaths column followed by a curt 'no cards.' Neither was any junketing laid on for the tenants as might have been expected. The young couple married on Wednesday 16 September 1867 when the bridegroom was only twenty. The Revd Walter Kelly performed the ceremony at St Andrew's Old Church, Hove. What a contrast to the lavish wedding (also conducted by the Revd Walter Kelly) when heiress Ellen Stanford married Vere Fane on 1 October 1867 at Preston.

John Olliver Vallance's grave in the churchyard of St Andrew's Old Church.

In the same year as his marriage John Olliver purchased the manorial rights for £801 1s 8d and thus became Lord of Hove Manor, Hove House being renamed Hove Manor. The young couple set up home not far away in Ivy Lodge while Mrs Vallance continued to occupy Hove Manor. Perhaps this was too close for Emma Kate and it is interesting to note that she did not conceive for several years, which certainly suggests an underlying tension. However once she was settled in a brand new home of her own, she lost no time in producing a family of five children. They were Henry John born in 1878, Arthur Charles Bertram born in 1879, Walter Claude Burrrell born in 1881, Ada Lilian Beatrice born in 1882 and Gladys Murielle May born in 1885. The new house was Brooker Hall built in 1877 to the designs of Thomas Lainson who was also architect to the Vallance Estate. It was named Brooker Hall in honour of his father's middle name. In 1891 the Vallances gave a dance at Brooker Hall to which around 200 guests were invited. Mrs Vallance wore a gown of terra cotta silk richly brocaded with flowers. The conservatory served as a sitting-out room and was charmingly decorated with Chinese lanterns.

J. O. Vallance took an interest in local affairs and he became a Hove Commissioner in 1874. In 1883 he was horrified to learn that Brighton

Connaught
Hotel
(P.H.)

Manor
House

IVY
LODGE

HOVE
LODGE

Ship
Inn

A sketch based on the 1899 map to show the location of Ivy Lodge.

District Tramway Company had plans to extend their tramway to Hove. This would have meant trams rattling past Brooker Hall because the Aldrington trams already stopped at the Hove boundary in nearby Westbourne Villas. The general public were in favour of such a scheme but it is said that J. O. Vallance was instrumental in getting the Hove Commissioners to throw it out.

In his younger days J. O. Vallance was a keen sportsman taking a particular interest in the Brighton Harriers founded by his father. The military life also appealed to him and he became an honorary major of the 3rd Battalion Cinque Ports Division, Royal Artillery. Later on he became a major in the Royal Sussex Artillery Militia. Another interest was yachting and he was a member of the Royal Thames Yacht Club and the Royal Victoria Yacht club, Ryde. It is claimed that the elevated folly on the roof of Brooker Hall was built at his special request so that he could take his spy-glass up there and look at the ships passing up and down the Channel. In 1890 he purchased a newly built cutter from the Shoreham yard of Stow & Son, which he named *Day Dream*. In 1891 her rig was altered to that of a schooner so that she had two masts instead of one and was of greater tonnage. It was in memory of the major's interest that Hove Regatta included a race over the Vallance Cup course (in 1910 it was a

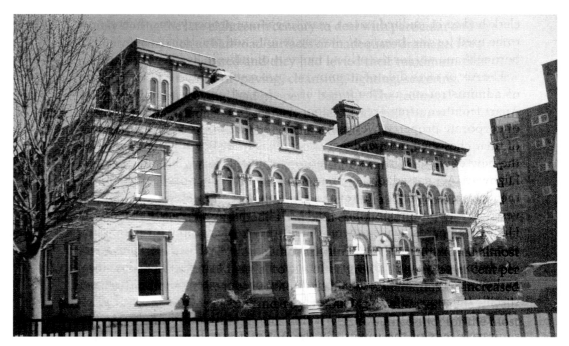

Brooker Hall, the family home of Mr and Mrs John Olliver Vallance.

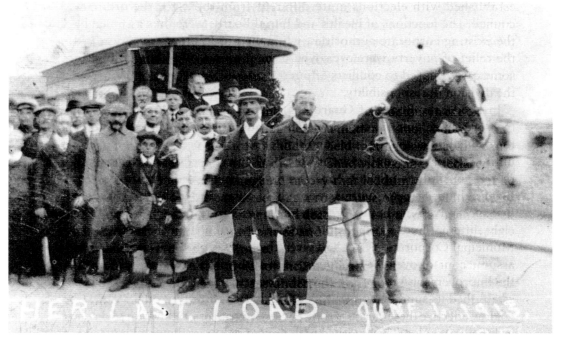

The last No 10 tram ran on 6 June 1913 from Shoreham to Aldrington's boundary with Hove. Major Vallance opposed the line's extension into Hove. (*Hove Library*)

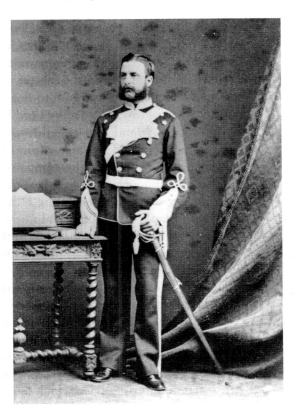

Major John Olliver Vallance (1847-1893) wearing the uniform of the Royal Sussex Artillery Militia. (*Hove Library*)

race for whalers). In 1892 the major took the *Day Dream* on a cruise in the Mediterranean and in September 1893 he returned to Hove after a yachting jaunt to Weymouth with his wife and family.

By this time his health was not good but it was still a shock when he died suddenly on 13 September 1893 in his forty-seventh year at practically the same age as when his father died. The funeral was held three days later at St Andrew's Old Church, Hove, on a day of pouring rain. Among the mourners were Captain Barnes and the crew from the *Day Dream* as well as relatives and workmen from the 'deceased's large estate.' In the press report it was stated that 'Major Vallance was really the squire of the place and was looked up to and highly respected. He was a considerable property owner and in fact his family has almost from time immemorial been actively associated with the township.' His grave is still to be seen on the south side of the church. It is an oblong of pink marble that was once enclosed by cast-iron railings. The inscriptions are somewhat worn but his name can be read as well as those of his mother and young brother.

J. O. Vallance's will ran to nine closely written pages and the gross value of his personal estate was put at £22,903 7s 8d – a considerable fortune in those days. The Vallance Estate stretched from the Aldrington boundary east to Hove Gas Works, and from the sea north to the Old Shoreham Road (its narrowest

The Brooker Hall Estate in around 1920.

part). The following are some of the roads built on former Vallance land. Aymer Road, Connaught Road, Frith Road, Landseer Road, Leighton Road, Poynter Road, Prinsep Road, Vallance Road, Vallance Gardens, Princes Square, Stirling Place, Pembroke Avenue, Pembroke Crescent, Byron Street, Coleridge Street, Cowper Street, Malvern Street, Montgomery Street, Monmouth Street, Shakespeare Street, Wordsworth Street, parts of Sackville Road, Portland Road, Blatchington Road and part of New Church Road.

On the face of it, his five children should have been guaranteed a very comfortable future but the tragedy was they were all under the age of twenty-one at his death. In a parallel with the Stanford Estate, it seems that when heirs are under-age children, the wealth is largely dissipated in legal fees. For example the Victorian and Edwardian eras were a busy time for house building at Hove but all the necessary land transactions had to pass through the hands of the Vallance Trustees who of course did not undertake the work for nothing.

Emma Kate received £300 per annum plus £1,000 from rents. But if she remarried she would lose her income. There is an interesting stipulation in the will, which leads one to suppose that perhaps J. O. Vallance regretted his youthful infatuation and early marriage. It stated that if any child contracted a marriage before the age of twenty-one without the consent of a guardian,

he or she would be disinherited. He also favoured a later age for inheritance – twenty-five instead of twenty-one. His brothers-in-law Sidney Livesay and H. R. H. Livesay, two of the executors, received £500 each but for the favourite sister-in-law Alice Maude Livesay he left £1,000 should she be still unmarried at the time of his death.

J. O. Vallance did his best to tie everything up so that his children would inherit the Vallance Estate more or less intact. The only parts he did not mind being sold off were plots of land developed for building purposes. But he did not want Emma Kate to sell Brooker Hall or the four acres surrounding it containing paddocks, lawns, gardens and outbuildings. His sons were to be given the option of purchasing the Manor House estate when they came of age at a price to be agreed. He was also anxious that all the old family silver, family portraits, linen, glass, china, books and furniture should go to the children. His widow might enjoy all these on trust but only if they were insured and taken care of properly. In view of this clause it is odd that in 1912 Mrs Vallance donated 117 miscellaneous volumes plus some important works on British birds to Hove Library. Perhaps the children were not interested. Mrs Vallance continued to live at Brooker Hall until 1914 and then she moved elsewhere but after she died in 1924 none of the children wanted the house and the Vallance Trustees sold it to Hove Council for £4,000 for use as a museum. Hove Manor was demolished in 1936 after Hove Council declined the opportunity of purchasing it on the grounds that the expense might put a shilling on the rates.

## Edmund Vallance and Vane de Valence Mortimer Vallance

Before following the fortunes of J. O. Vallance's five children, there is another member of the Vallance's extended family to consider. His name was Edmund Vallance and he was descended from James Vallance, one of the three brewing Vallance brothers. Edmund's father Charles had set up as a miller and brewer in Bristol and Edmund was born at 13 Edward Street, Bath in 1841. Like his cousin Benjamin Vallance, Edmund decided that brewing was not for him and he too followed a career in medicine. Edmund received his training at the Sussex County Hospital and in 1865 he was ordered to India as a staff assistant surgeon. He served with the 3rd Dragoon Guards in 1867, the 2nd Dragoon Guards in 1868 and it was probably straight from India that he joined the Abyssinian Campaign. He took part in the famous expedition under Sir Robert (later Lord) Napier to rescue the British consul and a group of missionaries who had been thrown into prison by the 'mad' King Theodore of Abyssinia. The expeditionary force travelled through more than 300 miles of unknown and precipitous country, stormed the capital and released the captives. Not a single man was lost in action and only 35 succumbed to disease. King Theodore later shot himself with the gun Queen Victoria had given him as a present.

In 1870 Edmund joined 19th Hussars, which the family always regarded as his regiment. This cavalry regiment was raised in 1857 by the British East India Company in Bengal but was transferred to the crown following the Indian Mutiny.

On 19 November 1872 Edmund married Jane Mortimer and he was placed on the reserve list in 1875. In 1881 and 1882 Edmund's elder brother Charles, and their parents died within seven months of each other. Edmund and Jane's first son Vivian was born in 1883 at 40 Westbourne Villas, Hove, but unhappily the baby only lived for six weeks. In 1884 the couple had twins, Vane de Valence Mortimer Vallance and Valerie.

The family home of long standing was at 38 St Aubyns. Edmund and Jane celebrated their Golden Wedding in 1922 and 'were literally loaded with flowers and many beautiful gifts.' The special cake was adorned with the same orange blossom and bridal flowers used fifty years previously. Ten years on they celebrated their Diamond Wedding anniversary. In a newspaper interview Mrs Vallance said that conditions of life for young people, especially girls, had changed much for the better. Marriage then was often drudgery for women who were worked almost to death because everything had to be done at home. Her governess taught her basic skills, a great deal of religion but nothing practical. To be ladylike was the most important consideration and if a girl went out in

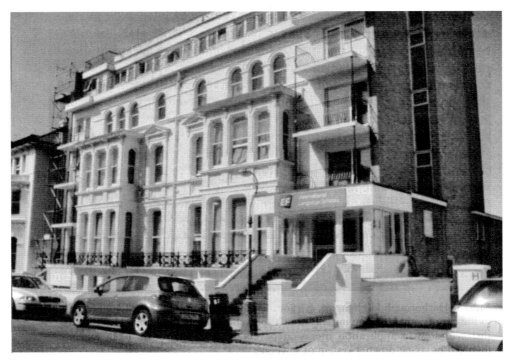

38 St Aubyns, the family home of Mr and Mrs Edmund Vallance.

the street without wearing a pair of gloves it was thought shocking.

Jane Vallance's father was Albert John Mortimer, British Paymaster-General to the German Legion in Hanover for twenty years. When he retired in 1862 he came to live at Brighton. Jane's brother, Charles Mortimer, was a tea and coffee planter in Ceylon for twenty-seven years and was greatly respected by the inhabitants. His workers were so attached to him that when he was ordered home because of illness, 200 came to say farewell, crying like children. He survived the voyage home but it exhausted him and he only had the strength to say a few words to relatives who had come to meet him. He expired at the very gates of Guy's Hospital in 1890.

Mrs Vallance was active in charitable causes and from 1885 to 1907 helped to organise the Sussex County Hospital Ball. During the Boer War she organised a Hospital Tobacco Fund and managed to send a quarter of a pound of tobacco to 1,450 men. The tobacco was despatched to South Africa together with 100 pipes donated by a Mr Wallis of Brixton in the care of Colonel W. H. Mortimer, chief paymaster, for distribution.

Edmund Vallance lived until the ripe old age of ninety-one and died in 1937. It is remarkable that a veteran of the Abyssinian Campaign of 1868 should have survived until almost the eve of the Second World War. Jane Vallance died in 1941 aged eighty-nine. She had become very deaf and used a large ear trumpet, which the grandchildren found alarming.

Vane de Valence Mortimer Vallance was born in 1884 and was christened at St Martin's Church, Brighton. It was a suitable choice because the church had military connections (soldiers stationed at Preston Barracks often attended services there) and Vane followed in his father's military footsteps. Vane was educated at Eton and from Sandhurst passed straight to the 5th Lancers in 1904. Being in a cavalry regiment obviously suited him because he was said to be a fearless cross-country rider. He became a lieutenant in 1905 and a captain in 1912.

In 1914 he was stationed at Marlborough Barracks, Dublin, and a photograph of four officers of the 5th Lancers, laughing and chatting, (with Vane on the right) was splashed across the front page of the *Daily Sketch*, (28 March 1914) which had this to say

All day yesterday the Army crisis was the great topic of conversation. The cabinet sat for hours; then, at last, Mr Asquith made his anxiously-awaited statement. Sir John French and Sir Spencer Ewart had been asked not to resign, he said, and new orders had been issued to the Army relating to what their 'duty' was. Above are four officers of the 5th Lancers, who played so prominent a part in the revolt, evidently much amused by the situation.

The 5th Lancers were one of the first regiments to be despatched to the Front when the First World War broke out. Vane was twenty-nine years old at the time. He was incredibly fortunate to come through the war unscathed because he saw continual action. He served at the retreat from Mons and at both battles

Vane de Valence Mortimer Vallance
(1884-1924) of the 5th Lancers. (*Vivien Vallance*)

A very different style of portrait of
Vane. (*Vivien Vallance*)

*Right*: Vane's Military Cross. (*Vivien Vallance*)

*Below*: General view of Brighton Extra-Mural Cemetery.

of Ypres. The 5th Lancers were the last British troops to leave Mons and the first to re-enter it in November 1918. Vane was awarded the Military Cross and was twice Mentioned in Dispatches. He was said to be a most popular officer and dearly loved by all ranks.

In the winter of 1918 Vane married Jessie Sangster Jamieson, whose father was a ship-owner. The young couple lived in a rented furnished house at 5 Vallance Road and it was there that their only child, a daughter called Vivien was born. Vane went on to serve with his regiment in India before retiring to Hove, by which time he was a major. But he did not have long to enjoy family life because he died suddenly on 8 July 1924. The circumstances were tragic especially after all the dangers he survived. He was walking along the cliffs at Black Rock and apparently testing the friable nature of the edge when he suddenly fell over. It was a drop of 80 feet to the beach below. The possibility of suicide was considered and rejected because he had been in a perfectly happy frame of mind and talked to a friend shortly before the accident. He was buried on 12 July 1924 in the family vault in Brighton extra mural-cemetery that also held his baby brother. It is sad to think of his parents in their old age with both sons dead. Vivien too felt an enormous gap in her life since she was only five years old when her father died. She had no memories of him but treasured his medals and portraits. She later lived in a lovely old house called Crispins, at Midhurst, but never married and died on 6 October 1990.

Meanwhile there was Vane's twin sister Valerie who was born with a deformed foot. She went on a trip to India and it is interesting to speculate if she was part of what was known as the 'fishing fleet,' that is eligible young women hoping to find a husband amongst the military personnel serving in India. Those who were unsuccessful in landing a husband and had to return home were known rather cruelly as 'returned empties.' But happily she found a husband on English soil in an old family friend, Colonel Roderick Needham.

Valerie Needham moved in society circles and her clothes were often described in the columns of Brighton Society. For instance, in May 1916 she had dinner at the Metropole with her brother Captain Vallance, home on leave. She wore a frock of blush-pink tulle with a swathed sash of Nanking blue brocaded in gold. A week later she wore a suit and a large black hat caught up on one side with a blue pom-pom – skunk furs completed the attire. On another occasion she wore a smart Georgette dress with a muslin collar and a high aigrette in her hat. Her daughters also came in for attention. Miss Yolande Needham was described as a 'bright clever little person with wonderful dark eyes and masses of lovely, curly hair ... a graceful dancer and gymnastic enthusiast.'

## John Olliver Vallance's Children

John Olliver Vallance and his wife Emma Kate had a family of five children. The eldest son born in 1878 was Henry John Brooker Vallance. He died at the age of twenty-one on 17 March 1899 after a fall from a carriage.

The second son Arthur Charles Bertram Vallance was born in 1879. He was described as 'a thorough sportsman, a good shot, a good man at the hounds, and rode, drove and motored well.' In April 1903 he married Ivy Campbell, only child of Colonel Archibald Campbell (late of the Bengal Staff Corps) and Mrs Campbell (daughter of a distinguished soldier – Major General Tronson). The wedding took place in Christ Church, Victoria Street, London, before a large and fashionable congregation. The bride wore a gown of white satin and her court train was held up by a little pageboy and there were four bridesmaids 'most becomingly attired.' The bridegroom's brother was best man. Mrs Vallance travelled up from Hove, no doubt privately comparing the splendid nuptials with her own modest wedding. The reception was held at Queen Anne's Mansions, St James's Park. Meanwhile, back at Hove, a celebration dinner was held at the Connaught Hotel in Hove Street and between ninety and 100 tenants of the Vallance Estate and representatives of the inhabitants of Hove were present. Included in the throng was J. H. Lee, coachman to the late Major Vallance. The chairman, Mr W. K. Stuart, said they were there to celebrate the marriage of the Squire of Hove who 'had taken up his position in the town of Hove with a modesty and urbanity, which had disarmed criticism and won many friends.' The Vallances honeymooned in Paris and afterwards returned to live at Hove Manor. However, the couple only stayed until 1906 and then the house was let. There were no children of the marriage and he died in 1934.

The third son Walter Claude Burrell Vallance was born in 1881 at Brooker Hall. He inherited his father's twin loves of yachting and the military life – he was in the local yeomanry and he became a lieutenant colonel. He married Cecily Ramshay, daughter of Thomas Ramshay of Heads Nook, Carlisle, Cumberland, in around 1905 and the wedding was a grand affair in London. The couple lived in a new house at 8 Vallance Road and there were two children of the marriage – Aymer de Valence Vallance born in around 1909 and Angela born in around 1911. In the 1912 Directory he was listed as vice-commodore and was one of the officials of Brighton Cruising Club. On the outbreak of war in 1914 W. C. B. Vallance was attached to the Naval Division of the Army and served in a destroyer before becoming a King's Messenger.

His wife, who was always referred to in the press as Mrs Claude Vallance, had a beautiful singing voice. In July 1915 an entertainment called 'A Gypsy Phantasy' was held at Brooker Hall to raise money for worthy causes such as the Women's Union fund and a hostel for lonely and convalescent soldiers and sailors. The show proved such a hit that it had to be performed three times. Mrs Claude Vallance 'looking a veritable gypsy' sang charmingly 'Where my

Caravan has Rested' and 'My Little Grey Home in the West'. Wounded soldiers were in the audience too. Mrs Claude Vallance and her mother-in-law took a great interest in the men's welfare and frequently visited them. Family legend has it that Cecily fell in love with a Canadian soldier. There must have been a huge family row because the Vallances separated – a fairly unusual step in those days – and the house in Vallance Road was sold.

By 1919 Claude Vallance had left Hove for good, taking his two children with him and also Daisy Poupard with whom he set up home in Devon and had a second family. Some say she was the children's governess. The unusual surname was French and the family traced their descent back to Nicolas Poupard, Lord of Buisson, who was granted a coat-of-arms in 1698. Daisy came from a large family of eleven children and she had a twin brother called Herbert. In fact there were so many children that Daisy was adopted and brought up by her uncle and aunt.

Claude decided to settle near the River Dart, no doubt so that he could continue to indulge in his love of yachting. In 1906 he had a boat called *Bingo* but in Devon his gaff-rigged yacht was called *L'Esperance* and was built at Shoreham. By the 1930s he had a yacht called *Margery* and she had an auxiliary engine. A showcase in the inner hall of his house was full of Claude's racing trophies.

He may have been a skilled sailor but he was hopeless at driving a car. Their first one was a Fiat but on an expedition to Paignton he failed to stop when a policeman on point duty held up his hand. He received a reprimand and shortly afterwards engaged a chauffeur called Jim who drove the family about

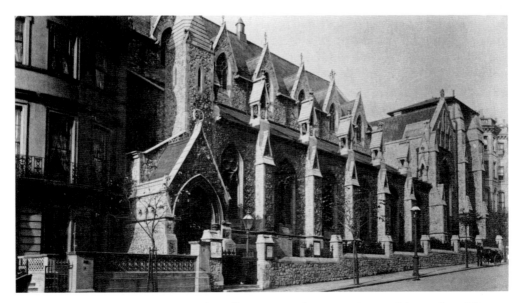

St Patrick's Church where in 1903 Ada Vallance married Captain Green of the 1st Royal Sussex Regiment.

in safety. A family catchphrase was Daisy's frequent lament 'Jim's here and nobody's ready.' By 1928 the Fiat had been replaced by a Clyno.

The Vallance's Devon house Kingswear was surrounded by pine trees and was built into the side of a hill. The drawing room and dining room were separated by double doors that could be folded back for special occasions such as Christmas when two extra leaves were inserted into the large oak table. A glass epergne was the centrepiece standing on a circular mirror. The epergne was piled with apples, oranges and tangerines, surmounted by a pineapple while around the base were arranged almonds, raisins, dates, dried plums, marrons glacé and crystallised fruits. On the wall there was a portrait of Claude's father and photographs of Laddie, his horse, and the destroyer in which he served. In the drawing room there was an oval table on which a collection of china was arranged. Violet the maid once sat a Vallance toddler on the table, which overbalanced and valuable heirlooms slid off and broke on the floor.

Ada Lilian Beatrice Vallance was the fourth child and eldest daughter of J. O. Vallance and she was born in 1882. In July 1903 she married Captain Edgar Walter Butler Green of the 1st Royal Sussex Regiment at St Patrick's Church, Hove. The bride was given away by her brother Arthur and she was described as 'handsome and vivacious in a wonderful gown of accordion pleated chiffon with lovely old rose print lace, the gift of her mother.' Her bouquet was of white orchids, white roses, stephanotis, lilies of the valley, orange blossom and myrtle. Her attendants were her sister Gladys and Miss Sadler, her cousin. They wore dainty dresses of white crêpe de chine and carried wands adorned with jasmine and lilies of the valley, tied with the colours of the Royal Sussex Regiment (blue and orange). Mrs Vallance's attire for the occasion was a handsome gown of pale blue crêpe de chine veiled with gold sequin net and trimmed with blue guipure lace. She had a toque to match and carried a bouquet of pale pink roses. 'Clusters of snowy white hothouse flowers, relieved by delicate ferns and other foliage plants graced the chancel.' The marriage produced two daughters and Captain Green ended up as a Brigadier General. He died in 1938 and was buried in Kelvedon Cemetery. In her second marriage Ada's husband was Dr Harold Drew Lander. She died on 26 December 1973.

Gladys Murielle May Vallance was the fifth child and second daughter of J. O. Vallance and was born in 1885. She married Richard Joseph Sharp and there was one daughter. Mrs Sharp died in 1970.

# Acknowledgements

Thanks are due to the following people for help and information:

Harold Lay and Ken Amiet, Beatrice Clissold, James W. Collins, Frank Knight, Jim Park, Denis Russell, Dorothy Sharp, Joe Vinall and Ken Lyon.

Thanks are also due to the ex-RAAF and ex-RNZAF men who wrote to me from the Antipodes. From Australia – Nobby Blundell, Wally Brue, George Cook, John Dack, Maurice Dunn, John L. Francis, Bob Hannay, Dick Higgins, F. C. Horley, Malcolm King, Arthur Leebold, Keith J. Oates, P. J. O'Connor, J. S. Otlowski (Polish Squadron RAF) Roy Powell, Jock Ross, Ray Sayer, Robert Smith, Glyn Thomas (RAF) Brian Walker, and Squadron-Leader P. A. Davidson.

From New Zealand – M Innes-Jones, Margaret McCann, Darcy Packwood, Doug Palmer, George Parry, Ian Simpson.

# Bibliography and Source List

## Hotel Metropole

Attwick, W. H. *Jubilee of Brighton Corporation* (1904)
Bingham, M. *Earls and Girls* (1890)
Clunn, H. *The Capital-by-the-Sea* (1953)
Clunn, H. *Famous South Coast Pleasure Resorts* (1929)
Cochran, C. B. *Cock-a-Doodle-do* (1941)
Cochran, C. B. *Secrets of a Showman* (1925)
Cochran, C. B. *A Showman Looks On* (1945)
Falk, Bernard *He Laughed in Fleet Street* (1933)
Gilbert, E. M. *Brighton, Old Ocean's Bauble* (1954)
Hickey, Des & Smith, Gus *Seven Days to Disaster; Sinking of the Lusitania* (1981)
Hotel Metropole, Sussex Pamphlets box 97 Brighton Local History Library
Hunt, Dick *Bygones* (1948)
La Bern, A. *Haigh, Mind of a Murderer* (1973)
Macqueen-Pope W. *Gaiety* (1949)
Montagu, Lord, of Beaulieu *The Brighton Run* (1990)
Musgrave C. *Life in Brighton* (revised 1981)
Roberts, H. D. *Book of Brighton*
Stone, L. *Road to Divorce, England, 1530-1987* (1991)

*Brighton Gazette*
5/1/1888
4/10/1888
11/10/1888
1/11/1888
10/1/1889
25/4/1889

24/10/1889
5/12/1889
6/5/1908
9/7/1913
12/5/1915
15/5/1915

*Brighton Herald*
12/4/1890
26/7/1890
9/8/1890
4/10/1890
14/11/1896
11/8/1917

*Brighton Society*
1890
1891
1892
1900
1916
1917
1918

N.B. *This chapter is an edited version of a privately printed booklet produced in 1992.*

## Lifeboats and Shipwrecks in Victorian Times

Log; extracted by H. Lowder King (*c.* 1930) from letters, minute books, records and reports returned to the RNLI. Brighton Library.

Minute Book of the Brighton Branch of the Shipwrecked Fishermen and Mariners' Benevolent Society 1839-1844. Brighton Library

Minute Book of the Hove General Purposes Committee 1881-1903. Hove Library

Details of Captain Collins' funeral cited in; Funeral Account Books of Attree & Kent;  Erredge J. A. *History of Brighthelmstone.* (Illustrated edition Brighton Library)

*Brighton Gazette*
15/1/1852
5/2/1852
20/5/1852
29/10/1857
5/11/1857
10/2/1859
7/4/1859
20/10/1859
18/1/1866
15/2/1866

6/6/1867
17/10/1867
20/11/1875
25/11/1875
2/12/1875
9/12/1875
11/1/1877
9/3/1878
21/1/1888
16/2/1888
9/3/1889
14/11/1891
19/11/1891

*Brighton Herald*
10/10/1857
12/2/1859
11/10/1890
31/8/1912

*Illustrated London News*
27/11/1875

Biggs, H. *The Sound of Maroons* (1977)
Bouquet, M. *South Eastern Sail* (1972)
Fry, E. C. *Life-boat Design and Development* (1975)
Howarth, P. *The Life Boat Story* (1957)
Howarth, P. *Lifeboat; in Danger's Hour* (1981)

Special thanks to the late Lieutenant Commander N. B. J. Stapleton, formerly publicity officer of the RNLI in the Brighton area.

*This chapter is based on a privately printed booklet produced in 1982.*

## The Vallance Family

Memorials – St Andrew's Old Church, Hove; St Michael & All Angels, Southwick.
Records of Brighton Extra Mural Cemetery.
Shoreham Shipping Registers, West Sussex Record Office.
Science Museum.
Patent Office.
British Library, India Office.
Brighton College Register.
Eton Records
Wills East Sussex Record Office Edmund V 1850 A83 / James V 1847 A82 / Maria Fayres V 1853 A84
Documents, East Sussex Record Office PAR 387/10/121 – PAR 387/10/123

SAC vols 55, 63. SN & Q vol6
Wooley, Bevis & Diplock, solicitors

*Advertiser*
13/8/1821

*Brighton Gazette*
21/9/1843
1/1/1852
25/4/1855
10/8/1865
9/11/1871
29/5/1884
24/7/1884
21/8/1884
4/9/1885
9/9/1885
14/9/1893
17/7/1915

*Brighton Season* 1912-1913

*Brighton Society*
2/8/1890
3/1/1891
5/5/1900
13/4/1916/
20/4/1916
25/5/1916

*Brighton Standard*
1/8/1903

*Brighton & Hove Herald*
9/11/1932

*Sussex Daily News*
20/11/1922 – 10/7/1924

Bishop, J. G. *A Peep into the Past* (1880)
Blaker, N. *Reminiscences*
Phillips J. R. S. *Aymer de Valence, Earl of Pembroke*
Robinson, M. *A Southdown Farm in the Sixties* (1938)

Special thanks to the descendants of the Vallance family for help and information including Miss Vivien Vallance, Miss Felicity Vallance, Mrs Penelope Chadwick, Mr Edward Haggar, Mrs Sonia Breeze, Mr Arthur W. Leonard, Mrs Biddy Hutson and Mike Strong, Brighton Fishing Museum.
    Thanks also to Michael Horscroft for assistance with the laptop.

## Vallance & Catt Ship Shares (64 shares a ship)

1824 – *AGNES* – 103 tons, square-rigger, built at Glasgow in 1824. Owners were James and Edmund Vallance. Vessel wrecked on Brighton beach in 1827.

1834 – *CHARLES* – 18 tons, hog boat, built at Brighton in 1816. Owner was William Catt, junior. Later broken up on Brighton beach but no date given.

1837 – *JOHN* – 178 tons, brig, built at South Shields in 1833. This ship was purchased for £1,250 from Brighton merchant John Cheesman Childers. She was owned by Edmund Vallance (21) William Catt, junior (21) William Catt of Bishopstone Tidemills (22). The vessel was lost off Shoreham 7 December 1849.

1838 – *KINGSTON* – 105 tons, schooner, built at Kingston in 1838, the first of May & Thwaites' ships from that yard. William Catt owned forty-eight shares and in November 1839 he sold eight shares to her master William Potter. Vessel was sold in 1843.

1840 – *PELHAM ARMS* – 15 tons, lugger, built at Shoreham in 1840. William Catt, junior, owned her and sold the vessel in 1844.

1841 – *PRINCESS ROYAL* – 39 tons, built by James Dowey at North Shields in 1841. She was built 'carvel from top to bottom, clench from bends to knee.' One of the first screw-steamers in the area. There were twenty-six shareholders including Edmund Vallance (2) William Catt, junior (4) and William Catt, senior (2). Henry Catt became the outright owner on 8 August 1842 and owned her for two years before she was sold and re-registered in London. In the gale of November 1843 the *Princess Royal* left harbour under the direction of Mr R. Buckman to aid any distressed vessels in the vicinity. She escorted the *Sarah Bell* and another distressed vessel back to port. She also found the spars of a sunken hull and towed that into harbour too.

1842 – *ELIZA JANE* – 195 tons, square-rigger, built at Sunderland in 1839. The owners were William Catt, junior (34) Edmund Vallance (7) George Catt, Newhaven miller (16) and William Catt, senior (7). In November 1842 shares were sold to John Horne in the following proportion; William Catt, junior (eighteen for £240) Edmund Vallance (seven for £92 10s) and William Catt, senior (seven for £92 10s). In 1844 William Catt, junior, sold his remaining sixteen shares to W. P. Gorringe for £400 but when George Catt sold sixteen shares a few months later, he only received £375. In November 1843 the *Eliza Jane* had discharged a cargo of timber from Archangel to Shoreham and had already left harbour when a gale sprang up. There was no pilot aboard and being unable to round Beachy Head she made a desperate run for harbour and 'almost miraculously escaped.'

1842 – *KINGSTON* – 23 tons, barge, built at Kingston in 1842. Owners were William Catt. Junior (22) Edmund Vallance (21) and C. N. Kidd, Steyning corn merchant (21).

1842 – *SARAH BELL* – 162 tons, schooner, built at Grimsby in 1838. Owners were William Catt, junior (43) and Edmund Vallance (21). In November 1843 when the gale blew up she was returning to Shoreham from Hartlepool laden with coal and lost her jib and a small portion of her bulwarks. *The Princess Royal* escorted her into harbour. In 1851 the vessel was re-registered as being owned by Vallance & Catt and unusually the owners did not have individual shares. They were James Vallance, gentleman, Charles Vallance, Charles Catt, Henry Catt, Brighton brewers, and William Catt the elder of Bishopstone.

1847 – *ELIZABETH* – 156 tons, square-rigger, built at Prince Edward Island, Canada, in 1846. Owners were Shoreham ship-owner William Mechen (22) Charles Catt (21) and Henry Catt (21). Vessel was transferred to Arundel in 1856

1847 – *ALFRED* – 214 tons, built at Kingston in 1847. Charles Catt owned sixteen shares. The vessel was lost in 1864.

1854 – *ADA* – 17 tons, smack, built at Gravesend in 1838. Owner was Henry Catt.

1855 – *WAVE* – 50 tons, schooner, built at Torquay in 1855, Owners were Henry Catt (32) and Charles Vallance (32). In October 1870 Henry Willett (formerly Catt) sold his shares and Vallance did too. The vessel was totally lost in Christiana Fiord on 7 October 1874.

1855 – *JANE HEWARD* – 171 tons, brig, built at Sunderland in 1848. Joint owners were Charles Catt and Charles Vallance. The vessel was sold to Whitby owners in 1865.

1856 – *OCEAN* – 148 tons, brig, built in Sunderland in 1856. Charles Catt owned twenty-two shares and John Catt, described as a Lewes gentleman, owned sixteen. The vessel was sold in 1858.

1856 – *JAMES DOUSE* – 138 tons, brig built at Prince Edward Island, Canada in 1856. Charles Catt owned her outright and sold her in 1867 to May & Thwaites. In 1872 while still owned by May & Thwaites the ship carried a cargo of coal from Swansea to Trouville. Her master William Patching sailed with a crew consisting of a mate, cook, one seaman and three apprentices.

1858 – *ROBINIA* – 219 tons, built in Canada in 1857. The owner was Charles Catt. On 18 August 1868 she was run down off Spurn Head Lighthouse and 'foundered about an hour after the casualty.'

1865 – *DARING* – 190 tons, built at Sunderland in 1865. The owners were Charles Catt and Charles Vallance, now both described as Brighton ship-owners. Like the Eliza Jane, the *Daring* sailed to Archangel, presumably for timber. Her rig was altered to that of a brig at least by 1874. In 1874 the Daring was entering Shoreham Harbour when she grounded on a shingle accumulation near the middle pier. As a licensed pilot was in charge at the time Vallance & Catt's attorney, Charles Lamb, held the harbour authorities responsible for the damage. Later Vallance & Catt claimed £349 19s 1d but the harbour authorities refused to pay up. In November Charles Vallance sold his shares but the *Daring* continued to be managed by the Catts.

1869 – *MERCHANT* – 282 tons, brig, built at Kingston in 1869. Owners were Southwick ship-owner John Sharp (36) and Charles Catt (28). In 1884 Catt sold his shares for £185 to John Sharp.

1871 – *MARINER* – 297 tons, brig, built at Kingston in 1871. Owners were John Sharp (36) and Charles Catt (28). In 1884 Catt sold his shares for £215 to Sharp.